Wacen Colour Painting

Robin Capon

DODGEVILLE PUBLIC LIBRARY 139 S. IOWA ST. DODGEVILLE, WI 53533

WITHDRAWN

Hodder & Stoughton
TEACH YOURSELF BOOKS

Acknowledgments

The author and publishers would like to thank the following for permission to reproduce photographs and illustrations (the numeral references correspond to illustration numbers): British Museum, colour plate 1; Rachel Capon, colour plate 12 and 55, Williamson Art Gallery and Museum, Metropolitan Borough of Wirral, colour plate 2. Except those listed above, all the illustrations are by the author.

For UK order queries: please contact Bookpoint Ltd, 39 Milton Park, Abingdon, Oxon OX14 4TD. Telephone: (44) 01235 400414, Fax: (44) 01235 400454. Lines are open from 9.00–6.00, Monday to Saturday, with a 24 hour message answering service. Email address: orders@bookpoint.co.uk

For U.S.A. & Canada order queries: please contact NTC/Contemporary Publishing, 4255 West Touhy Avenue, Lincolnwood, Illinois 60646–1975, U.S.A. Telephone: (847) 679 5500, Fax: (847) 679 2494.

Long renowned as the authoritative source for self-guided learning – with more than 30 million copies sold worldwide – the *Teach Yourself* series includes over 200 titles in the fields of languages, crafts, hobbies, sports, and other leisure activities.

A catalogue entry for this title is available from The British Library.

Library of Congress Catalog Card Number: On file

First published in UK 1998 by Hodder Headline Plc, 338 Euston Road, London, NW1 3BH.

First published in US 1998 by NTC/Contemporary Publishing, 4255 West Touhy Avenue, Lincolnwood (Chicago), Illinois 60646–1975 U.S.A.

The 'Teach Yourself' name and logo are registered trade marks of Hodder & Stoughton Ltd.

Copyright © 1998 Robin Capon

In UK: All rights reserved. No part of this publication may be reproduced or transmitted in any form or by any means, electronic or mechanical, including photocopy, recording, or any information storage and retrieval system, without permission in writing from the publisher or under licence from the Copyright Licensing Agency Limited. Further details of such licences (for reprographic reproduction) may be obtained from the Copyright Licensing Agency Limited, of 90 Tottenham Court Road, London W1P 9HE.

In US: All rights reserved. No part of this book may be reproduced, stored in a retrieval system, or transmitted in any form, or by any means, electronic, mechanical, photocopying, or otherwise, without prior permission of NTC/Contemporary Publishing Company.

Cover: An abstract expressionist watercolour by the author.

Typeset by Transet Limited, Coventry, England.

Printed in Great Britain for Hodder & Stoughton Educational, a division of Hodder

Headline Plc, 338 Euston Road, London NW1 3BH by Confe Wyman Ltd, Reading Berkshire.

139 S. IOWA ST.

Impression number 10 9 8 7 6 5 4 3 2 1 DODGEVILLE, WI 53533

Year 2004 2003 2002 2001 2000 1999 1998

CONTENTS

	Introduction	_1
	PART 1: MATERIALS AND METHODS	
1	What is Watercolour?	_ 5
2	Choosing your Materials	_ 12
3	Colour and Colour Mixing	_ 28
4	Learning the Basic Techniques	_40
5	Progressing to Advanced Techniques	_ 59
6	Keeping a Sketchbook	_71
	PART 2: IDEAS AND PROJECTS	
7	Planning your Painting	_ 86
8	Painting from Observation	_ 97
9	Painting Outdoors	_ 105
10	Painting from Sketches, Drawings and Photographs	_ 115
11	Using your Imagination	_ 122
12	Developing your Ability	_ 130
13	Framing and Displaying your Paintings _ Glossary	_ 136 _ 144
	Further Reading and Resources	_ 150 _ 153

About the author

Robin Capon is a freelance writer and artist. He is the author of 14 books on art and craft techniques including *Teach Yourself Drawing*, also published by Hodder and Stoughton. He has written for a variety of publications and is a regular contributor to *The Artist* and *Leisure Painter* magazines. His paintings are sold through private commissions and a number of provincial galleries, and he also works as an art and design examiner for two of the main examining groups.

INTRODUCTION

Painting is a way of expressing your ideas and feelings. You can have a lot of fun mixing colours and experimenting with different subject matter and techniques, and there is nothing quite like the thrill of completing a painting that has worked well and has perfectly captured the idea you had in mind. Watercolour is a good painting medium to choose. Ignore those who say it is temperamental, uncontrollable or even impossible! This is not/so. In fact, once you have gained some confidence with the basic watercolour techniques, and these are not difficult to grasp, you will soon find that you can achieve just the effects you want. You will discover that painting in watercolour is an exciting and rewarding activity.

One of the great characteristics of watercolour is that it is extremely versatile. You can use it for any subject matter and you will discover that there are many techniques and processes to choose from. A watercolour can be a simple line and wash painting or, contrastingly, developed with a variety of methods into an immensely detailed result. Although there is a traditional way of creating a watercolour painting with a succession of thin, transparent washes of colour, there is no 'proper' method which you must use. In fact, many notable watercolourists, including Turner, Girtin, Cozens, Cotman and Palmer, used techniques which varied from the accepted norm. Even Sandby, who is often described as 'the father of watercolour painting', incorporated both wash and opaque effects in his work. Every watercolourist paints in a slightly different way. As you gain experience you will begin to find the subjects, methods and approaches which work best for you and so start to develop your individual way of painting in watercolour.

Paintings are made for different reasons. You may find that you prefer to paint from careful observation and show things accurately and realistically. Alternatively, you may want to express your feelings and interpret something in a personal, free and uninhibited way. Your

paintings could develop from an emphasis on strong foundation drawing or as direct applications of colour washes. You will see from the various illustrations in this book that watercolour will suit a wide range of approaches. It is wonderful for capturing a fleeting moment or movement and character and, equally, it is marvellous for showing the drama of light and dark, creating a sense of atmosphere and conveying your personal impression of a scene, as in illustration 1 and see also plate 6.

Often, a limited use of colour and technique works best, so that the result is not overstated or overworked. *Greta Bridge* by John Sell Cotman (plate 1) is a fine example of this. Notice how a simple subject expressed with feeling can be very telling – paintings do not have to be complicated.

Progress depends as much on enthusiasm and application as it does on acquiring new skills. If you really want to paint and are willing to practise and persevere, then you will succeed. I cannot pretend that watercolour painting is easy, but I think you will find that by following the carefully planned course in this book you will gradually learn and gain confidence. Some topics will look intimidating, but don't be afraid to have a go. It is essential, I believe, that you aim for a good general experience of the medium before attempting a degree of specialism. Take your time, paint as often as you can, and accept the disappointments as well as the successes. Not everything will go right at first but you will, in fact, learn a great deal from your mistakes!

I firmly believe that everyone has a degree of natural ability and that this can be developed, given the right sort of instruction and a positive attitude from the student. Success will also depend on mastering some drawing skills and learning to look at things with enquiry and perception. You will see that I encourage you to keep a sketchbook and draw as often as possible. In addition to trying out methods, processes and ideas, you will learn by looking at other artists' work. The best way to do this is to visit galleries and exhibitions and view as many actual paintings as you can.

There are two parts to this book. Part 1, Materials and Methods will help you decide what materials you need, how to test these and develop some confidence in handling them, and how to mix and use colour. Additionally, you will be encouraged to try out all the basic techniques

INTRODUCTION 3

and you will be shown how to sketch and plan your ideas. Working from this foundation course of information, activities and experience, you will be able to progress to Part 2, *Ideas and Projects*. Here, the basic theory is put into practice through reference to different subject matter and approaches. Aspects such as composition, working outside, and expressing feeling and atmosphere are also included.

At the end of most sections you will find *Projects*. These projects are carefully devised to help you revise all the previous information in a practical way. The projects are essential for your development and you should tackle them all. Using this well-structured approach you should be able to build on the information, examples, suggestions and topics, so gradually improving your watercolour painting skills.

Watercolour is a sensitive medium and by its very nature a technique such as painting wet-in-wet will involve a degree of chance. It is the medium of thin, transparent washes, of luminosity, of fresh, pure colour, atmosphere, mood, feeling and expression. It is a superb medium for capturing the fleeting effects of skies and the moods of landscape, just as it is for many other subjects. Initially, putting brush to paper seems a rather daunting prospect, but those first blushes of colour will, I am sure, soon entice you to have a go, enjoy yourself, and work for increasingly better and more rewarding paintings.

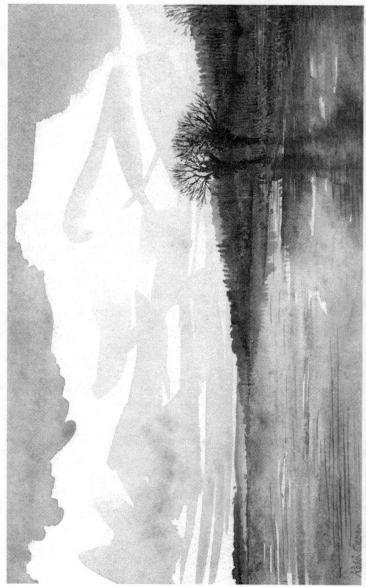

WHAT IS WATERCOLOUR?

Many artists enjoy watercolour because it is a fresh, spontaneous and direct medium to use. Applied to white paper its colours are translucent and glowing while, by involving only a few simple overlaid washes, it is possible to create an almost instant suggestion or impression of the subject matter. A great strength of watercolour is that it encourages individuality and innovation: it does not rely on a prescribed process or method. Today, artists are keen to explore and exploit the immediacy and fluid nature of watercolour. A look around any exhibition, particularly major ones such as the annual Singer & Friedlander/Sunday Times Watercolour Exhibition at the Mall Galleries in London, will demonstrate the huge variety of styles and approaches that is possible.

A versatile medium

Traditionally the technique of pure watercolour uses a dark underpainting with a number of broad washes of colour applied over this. The light areas, whites and highlights are left as untinted paper, something which is known as 'reserving the lights'. Dark values and strong colours are evolved through a succession of superimposed colour washes and the paint handling and general treatment is kept simple.

Some contemporary watercolourists like to stick to this traditional approach, believing it to engage the true virtues and aims of the medium. Others, however, prefer not to work within any boundaries. They may use watercolour in conjunction with gouache to provide specific overpainted white areas or contrasting passages of opaque colour, for example. Or they may experiment with combining watercolour with other media or using unconventional techniques such as scraping back or wax resist. They see watercolour as an exciting medium, full of

potential: a medium in which they can find their own personal style and means of expression. Plates 1 to 12 show a range of possibilities.

The essence of many watercolours lies in the deft beauty created by a series of thin washes of colour, and it is these which give the paintings spontaneity, vigour and impact. As you can imagine, handling very fluid paint is no easy task and frequently involves an element of chance. For some artists this risk element is an attraction. They relish the fact that the direction and aims of the painting cannot be entirely pre-planned, that they must think and act quickly and that opportunities to make use of fortuitous blobs and runs of colour must be capitalised upon. Watercolour has a reputation for being a difficult medium to control and this deters some people. But, as many artists show, it is possible to retain the essential spontaneity of the medium while at the same time working in a controlled way and defining the special attributes of the subject matter.

So, there will always be opportunities to exploit the varied properties and characteristics of this medium. In some instances, as with a moody landscape like the one shown in plate 8, it will pay to take risks and make use of those barely controllable washes to give an atmospheric, impressionistic quality. In other paintings, see plate 7, you may decide to mix thicker paint or even add some gum arabic or a similar medium to the pigment to give it extra body and make it less runny and easier to blend. As you will see in the following chapters, watercolour offers all sorts of techniques and effects to choose from. Contrary to those generalised comments inferring difficulties and restrictions, watercolour is a versatile medium full of exciting possibilities.

Watercolour paints are made from finely ground pigments dispersed evenly in a gum arabic solution or similar water-soluble gum binder. While acting as an agent to hold the pigment intact, the gum binder also allows the paint to be heavily diluted with water and so used to make weak, transparent washes of colour. Also, a small amount of glycerine or honey is usually added to the paint to improve its solubility and some ox gall is included to enhance paint flow. Lightfastness and permanence are other qualities which are considered in the manufacturing process. Generally speaking, artist-quality paints are the best in this respect. Suppliers' charts and literature will specify lightfastness and permanence ratings if these are not marked on individual pans and tubes.

Historical background

As a distinct painting medium in its own right, watercolour is a comparative newcomer when viewed in the general context of the history of art. Its golden age was in England in the mid-nineteenth century when, in a period dominated by a fervent interest in landscape and nature, the particular qualities of the medium were regarded as especially suitable for capturing atmosphere, ephemeral effects and the picturesque. The wonderfully sensitive and dramatic landscape pictures of that time evolved from an earlier topographical form of painting which was used by travelling artists to make visual records of country houses and their grounds for wealthy patrons. From this line and wash technique, with the watercolour subordinate to the drawing, the emphasis gradually shifted in favour of colour. Throughout the late eighteenth and early nineteenth century watercolour became an established and popular medium.

However, its origins date from many centuries earlier. Water-based paint was one of the media used by the ancient Chinese to paint the landscapes and other scenes which illustrated their calligraphy. Similarly, as early as 1000 BC, the Egyptians used earth and mineral pigments blended with gum arabic and egg white and diluted in water to create the transparent colours which they painted on papyrus rolls. Later, when parchment was available, manuscript illustrations and miniatures were often painted with a mixture of watercolour and lead white, producing opaque colour. By the late Middle Ages the use of watercolours by limners and painters of miniatures was widespread.

From Renaissance times to the late eighteenth century watercolour became a recognised technique, although in general it was confined to the preliminary roughs and studies made for large oil paintings. However, some artists saw the potential in using watercolour for its own sake. Undoubtedly one of the first masters of watercolour was the great sixteenth century German painter and engraver Albrecht Dürer. During his lifetime he painted more than 80 watercolours, these showing exceptional skill both in a fluent, economical style as well as in a controlled, highly realistic approach.

It was in the seventeenth century that artists began to explore the possibilities of a loose, wash technique, sometimes, as with Claude Lorraine,

working directly from the landscape. This wasn't true watercolour as we know it today, rather the use of sienna, sepia and umber washes to provide a reference for tones and composition. Rembrandt too made hundreds of sketches in brown bistre or sepia wash. In the following century, when it became fashionable to travel throughout Europe on what was known as the Grand Tour, there was an increasing demand for hand-coloured etchings of Venice, Rome and other notable places and sights. In time, the watercolour itself became more important than the etching.

From Hogarth and Gainsborough in the late eighteenth century to Sandby, Towne, Cozens, Rowlandson, Girtin, Cox, de Wint, Constable, Turner, Cotman and the other great masters of the nineteenth century different watercolour techniques were developed, both for the spontaneous and the studious approach. Styles range from William Blake's extraordinarily imaginative illustrations to Turner's exceptionally direct and atmospheric landscapes, seascapes and interiors, and the characteristic tones of gold and white gouache included in Samuel Palmer's Shoreham period watercolours. In addition, watercolour painting interested many amateur artists and it became known as 'the English national art'.

One of the best landscape artists of this period was John Sell Cotman. As his painting *Greta Bridge* (plate 1) shows, Cotman used the classic technique of pure watercolour, involving a dark underpainting and a few, broad washes of colour. If you study this painting you will see how the artist has placed a lot of emphasis on well-drawn, simplified shapes, careful composition, and harmonious colour. These three important elements are well worth remembering when you come to paint your own watercolours. Now compare Cotman's watercolour with *A Windy Day* by David Cox (plate 2). Here, broad washes have been combined with small areas of colour and even individual brushstrokes. This wonderful handling of paint creates a tremendous sense of mood and atmosphere.

The success of watercolours in England spread to Europe and other parts of the world. For some artists watercolour became the favoured medium for setting down ideas encountered on their travels. The French artist Delacroix used the medium in this way, collecting numerous studies of animals and other subjects. Such paintings sometimes worked as successful pictures in their own right, or could be used as reference for

oil painted works. Many well-known painters worked in both oils and watercolours, including some of the precursors of Impressionism such as Jongkind, and later artists such as Cézanne.

The first truly abstract work was a watercolour by Kandinsky painted in 1910. More recently, especially in the US with Edward Hopper, John Singer Sargent and contemporary artists like Charles Reid, watercolour is used with a new force and often immense skill and inventiveness. From wet-in-wet abstracts to expressionist landscapes or photo-realist portraits, artists are proving that watercolour is not the limiting and perhaps erratic medium that it was once thought to be. Rather, it is a liberating medium, allowing all manner of styles and techniques. Certainly, it has come a long way from those early tinted drawings!

Of course, this has been only a brief glimpse at some of the principal developments in the history of watercolour painting. If you would like to study this aspect in more detail then consult publishers' lists and your local library for those books which specifically cover different artists and periods. There is always something that can be learned by studying the paintings of other artists, whether these are from the past or being viewed at a contemporary exhibition. We can learn by looking just as we can by practising, and other paintings will often reveal helpful methods as well as inspiring ideas.

Exploring watercolour

In its variety of subject matter, techniques and styles, the history of watercolour painting shows that there is actually no one way of painting with this medium, no 'proper' method. Like any form of creative expression, watercolour painting is a means of communicating an artist's particular ideas in an individual way. Presented with the same subject, each artist will wish to interpret it with a different emphasis and therefore engage whatever approach and methods seem necessary. When I paint the sort of landscape scene shown in illustration 2, for example, I prefer not to do any preliminary drawing but to start directly with some basic washes to block in the main areas of colour. I then work over these, wash on wash, to whatever extent is necessary to build up the required tones and detail.

In time, this special process of seeing and interpreting, combined with the way that we gradually adapt basic techniques to suit the desired aims for our paintings, creates a personal style. Your personal style will depend on a willingness to explore the medium and find out how it responds and what it will do for you. The confidence to experiment and discover will, of course, come from first establishing a sound working knowledge of the basic techniques. It is important to persevere with these until you feel satisfied that, whenever appropriate, you can incorporate any of them into your paintings. Naturally it takes a good deal of time, patience and practice to reach a stage of total confidence. Indeed, because of the nature of watercolour and the fact that every picture should be something of a new experience and discovery, arguably no artist should feel absolutely sure about how a painting will develop.

In the next few chapters you will learn about paints and other necessary materials and how to mix colours and try out various techniques. This will provide you with a sound basis from which to tackle the ideas and projects in Part 2 and thereafter on which you can build some experience and understanding as you work towards your own style of watercolour painting.

Project

Take a careful look at plates 1, 2, 6, 7, 11 and 12. Compare the different approaches and techniques used in these paintings.

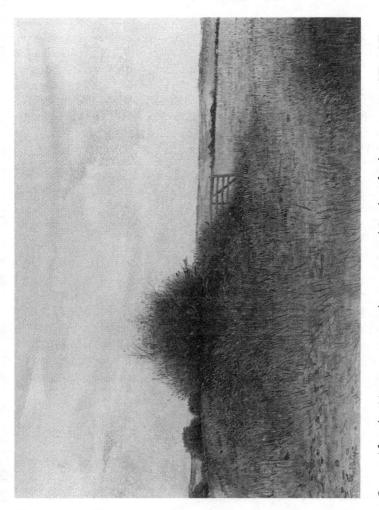

After the Harvest, watercolour on tinted Bockingford paper, size $27 \times 37 \text{cm}$

2 CHOOSING YOUR MATERIALS

You may be surprised to discover that you won't need a great quantity of materials and equipment in order to paint a good watercolour. Fine paintings, of course, rely more on the skills of the artist than on lots of expensive brushes and paints. Indeed, there are distinct advantages in working with a limited range of equipment. Quite apart from the fact that you will save money by not buying unnecessary items, a restricted approach will prove less confusing and, especially where colour is concerned, generally more successful.

Another reason why it's best to keep to a few brushes and paints to begin with is that, until you have practised and experimented for a while, you won't know which techniques, subjects and so on are going to suit the way you want to work. As you gain some experience and begin to evolve a style of your own then you may need to buy particular brushes, colours, types of paper or other materials and equipment which will help you achieve the special effects you desire. In time, most artists begin to favour certain brushes, colours and methods of working. When you have mastered the basic techniques and developed some confidence, then the choice will be yours as to which materials and equipment you want to use.

This chapter gives you plenty of information on the wide range of materials and equipment that is available, more in fact than you actually need to get started. Having read it through, you can refer back to it later when you wish to try out different techniques or add to your basic range of equipment. A recommended list of equipment for beginners is given at the end of this chapter. Always buy the best equipment you can afford and take the trouble to look after it. Good quality materials will last longer and will help you achieve better results. Find a reputable specialist art shop which will be able to offer advice and let you handle and try out materials.

Paints

In art shops you will notice that there are two types of watercolour paints: artists' quality and students' watercolours. While students' watercolours are perfectly adequate to begin with, they do not have the same richness of pigment or degree of permanency that is found in the more expensive artists' quality paints. Incidentally, the permanency rating, along with the other information, should be indicated on the paint tube label or the pan colour wrapper. Usually, permanency is shown as a star rating, with one star being non-permanent and four stars quite permanent. If you can afford them, buy artists' quality colours.

The next choice relates to tube colours or pan colours. Tubes are available in various sizes, from 5 ml to 21 ml or larger, while pans take the form of small square-shaped blocks (half pans) or oblong blocks (whole pans). A fitted box of watercolours will have a selection of pan colours to work from. Alternatively, you can buy an empty watercolour box which has a number of wells into which you can fit your own choice of pan colours or squeeze out colours from tubes. You don't have to stick to one brand of paints – good quality watercolours are compatible across different makes.

Artists have their own preference as to whether they use tube colours or pan colours. There are advantages and disadvantages for each type. Many landscape painters prefer tube paints, while flower painters, who like a wider range of colours and perhaps rely less on broad washes, usually work from pans. The danger with pans is that if the brush is dipped in one colour and then the next, the paints soon become muddy. Because the paint is solid, mixing washes inevitably causes more wear and tear on brushes. So, when working with pan colours, make sure the paints are kept pure by wiping them with a clean sponge. Some artists keep a damp cloth in the box so that the paints stay moist and are consequently easier to mix.

Tube paints contain additional glycerine and are therefore more soluble. The advantages of tube colours are that they are easier to mix, especially for large washes, and they are less likely to produce soiled colours. Also, tube paints are easier on brushes, because hardly any scrubbing motion is required to pick up the colour and, of course, you can buy individual tubes of paint as you need them. The disadvantage of tubes is that there

is always a temptation to squeeze out too much pigment, although dried paint can sometimes be re-wetted and used in the normal way.

For those just starting to paint in watercolour I advise that you buy a small box of artists' quality pan colours (whole or half pans). In my experience beginners work more confidently from these colours, which they can readily see and mix. Look for a box which has no more than 10 or 12 colours and which also gives you some good-sized mixing areas in the lid, see illustration 3. A list of recommended 'starter' colours is given at the end of this chapter. It isn't essential that your watercolour box matches up to these exactly, as long as it provides the same scope for mixing a good variety of colours.

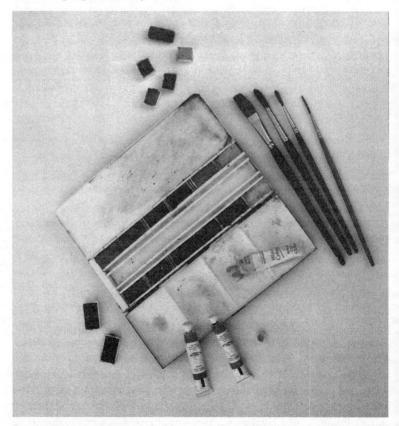

3 A watercolour paintbox, various pan and tube colours and the basic set of brushes

Try out all the colours in your paintbox and experiment with various combinations and mixes. This is the best way to learn something about colour and understand the nature of the different pigments. Some, as you will find, are much stronger than others and consequently are likely to dominate a colour mix or wash unless used in a very diluted form.

As your colour sense develops and your individual style begins to evolve you may prefer to work to a particular palette (range of colours). Many landscape artists, for example, choose quite a limited palette – perhaps ultramarine, cobalt, lemon yellow, yellow ochre, raw umber, burnt sienna, burnt umber, alizarin crimson, cadmium red and Payne's grey. Notice that these are mostly cool colours and earth colours and that green is not included. Most artists prefer to mix greens rather than use a manufactured green straight from the tube or pan. A limited palette is often beneficial towards creating colour harmony and contrast in a painting. If you look at plate 8 you will see that it was painted using only three colours.

Brushes

Paints, brushes and paper are the three key elements in watercolour painting: the right choice of each of these helps us to create the desired quality and effects in our work. Brushes are certainly no less important than paints and paper.

A good watercolour brush can hold a large quantity of paint and release as much or as little as you wish. The hair of the brush should be fine yet resilient and capable of tapering to a sharp point so that details are possible, even with the largest brush. The best brushes have a spring and flexibility which allows both spontaneity and control. Look for brushes which have a seamless ferrule (the wrap-round part which holds the hairs in place) and a firm, well-shaped handle.

Sable brushes have all these characteristics and without doubt are the best for watercolour painting. Ideally, buy red sable or pure sable brushes or, if you can afford them, Kolinsky sable. These superior brushes traditionally have black handles and are made from the tail hair of the Siberian Kolinsky mink. Be suspicious of inexpensive sable brushes. These are often a mixture of sable hair and synthetic fibres. It is safest to buy recognised good quality brands, such as Winsor &

Newton, Daler-Rowney, Pro Arte, Isabey and Raphael. Providing they are looked after, quality brushes will prove a worthwhile investment, not only economically but also because of the type of work which is possible.

If you cannot afford sable brushes or dislike the fact that they are made from animal hair, combination brushes (those with a mixture of natural and synthetic hair) or synthetic fibre brushes will make a reasonable alternative. However, they won't have quite the same spring and sensitivity in use and they are more likely to shed hairs and wear out more quickly. You won't need many brushes to begin with, as shown in illustration 3. A list of recommended types and sizes is given at the end of this chapter.

Most art shops stock a wide choice of brushes and you will see that these are classified under different names, such as rounds, mops, wash brushes, hakes, flats, fans, filberts, riggers and Chinese brushes. Some are available as either short-handle or long-handle versions. The shape, size and variety of hair used to make a brush all contribute to giving it certain characteristics which, in turn, make it suitable for particular techniques. Flats, filberts and fan, for example, can be good for drybrush work; hakes and mops are splendid for laying in large areas of wash; riggers and designers' brushes are ideal for details; rounds and Chinese brushes are generally the most versatile, suiting a range of techniques.

Don't expect every type of brush to be available in sable hair. Large mop brushes, for instance, are often made from goat hair, which has excellent water-holding characteristics, while wash brushes are frequently made from blended hairs. The basic selection of brushes listed at the end of this chapter will give you plenty of scope to begin with, although as your painting skills develop you may wish to add other types or sizes of brush to cover particular techniques and effects. After buying a new type of brush, get to know its capabilities by testing it out on some scrap paper, as shown in illustration 4. See how the pressure you apply to the brush and the way that you hold it affect the kind of lines and strokes it will make. Try a small painting using just one brush and experimenting with various effects.

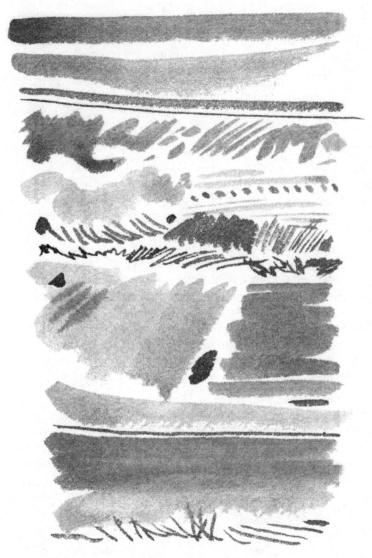

Test your brushes like this, with various marks and washes of colour

Always clean your brushes thoroughly after use and reshape the tips using your thumb and forefinger or a soft rag. Don't leave them standing in water for hours at a time, as this will damage the hairs. When not in use, store your brushes flat in a tray or drawer, or place them upright in a jar, handle first.

Paper

The choice of paper plays a significant part in determining the degree of success of various painting techniques. Watercolour papers are available in three different types: hot-pressed (H-P); cold-pressed (Not); rough. These names are an indication of the surface texture. Hot-pressed has a smooth, fairly firm surface, which is good for controlled work, though not ideal for general washes. Cold-pressed, which is also known as Not (or not hot-pressed), has a slightly textured surface and is suitable for most techniques. Contrastingly, rough paper has an obvious tooth or surface texture which suits dry-brush techniques and broken washes. This paper will also stand up to a lot of wetting, lifting out, scratching-back and so on. Additionally, papers can be handmade, mould-made on a cylinder-mould machine, or machine-made on a fourdrinier machine. Handmade papers have an irregular texture and are the most expensive. Machine-made papers may have a mechanical, regular surface grain.

In essence, watercolour relies on a sequence of washes and therefore a good watercolour paper must be able to absorb a great deal of water without buckling or allowing the colours to run. Manufacturers overcome these problems by sizing the paper. When well sized it will accept wash tints, erasing, scraping-back and other techniques and yet continue to allow the colours to remain brilliant and transparent.

It's helpful to experiment with different kinds of papers to see how they respond to your working methods, but start with a standard 140 lb/300 gsm watercolour paper manufactured by one of the well-known suppliers. Bockingford paper, which is a mould-made, Not surface paper, is a popular and reliable general-purpose type which is widely available. Later, depending on the sort of subjects and effects you want to produce, you can adjust the type of paper accordingly. For a heavier-quality surface, try Saunders Waterford Rough.

You can buy paper in sheets, pads and blocks. Sheets are the most economical and you can cut these to whatever size and shape you require. Most paper is white or off-white, although you can also buy tinted papers. Watercolour paper is sold in a variety of sizes and weights. The most common sizes range from medium $(22 \times 17^{-1/2} \text{ in/559} \times 444 \text{ mm})$ to Imperial $(30^{-1/2} \times 22^{-1/2} \text{ in/775} \times 572 \text{ mm})$, with weights varying from 72 lb/150 gsm to 400 lb/850 gsm. The weight or thickness of watercolour paper is traditionally stated in pounds per ream of Imperial-size sheets, but is now also shown in grammes per square metre (gsm). Lighter papers tend to buckle and distort when washes are applied.

Stretching paper

When a sheet of watercolour paper is wetted, the fibres within the paper soak up the moisture and swell, thus causing the surface to buckle. With heavier papers this distortion is less marked and may perhaps disappear as the paper dries. Some artists are prepared to accept a little unevenness in the surface appearance of the finished painting, preferring to work on unstretched heavier papers which suit particular techniques and effects. However, thinner, lighter-quality papers, 140 lb/300 gsm or less, must be stretched prior to use.

Preparing boards with stretched paper is an irksome yet necessary practice for the watercolourist. If possible, the best approach is to prepare two or three boards at once so that there is always a supply of stretched paper available. The method uses brown gummed-paper strips to fix the edges of a wetted sheet of paper to a stout board. Secured by the gummed strips, as the watercolour paper dries so it contracts and pulls out absolutely flat. It may wrinkle again while the painting is in progress, especially when heavy washes are applied, but as long as it is fixed to the board it will always dry flat. A large stretched sheet of paper may do for two or three small paintings, providing none is cut from the board until all are finished. Many artists have their own variant of the basic method.

Method

■ You will need a sheet of watercolour paper, a drawing board or similar thick board, a roll of 2 inch/50 mm brown gummed paper, scissors a sponge and a clean sink or deep tray of water. Do not try to stretch paper on thin board such as hardboard or medium density fibreboard (MDF), which

will warp under pressure. Instead, choose boards which are made from 5/8 in/16 mm plywood or a similar firm board available at DIY stores.

- Trim the watercolour paper so that it is at least 1½ in/38 mm smaller all round than the board.
- Cut a length of brown gummed paper for each of the four edges of the board, allowing for an overlap of about 1½ in/38 mm at both ends.
- Immerse the sheet of paper in clean water for a minute or two, ensuring that both sides are really wet. Heavier-quality papers will need longer. Make use of the bath for large sheets of watercolour paper.

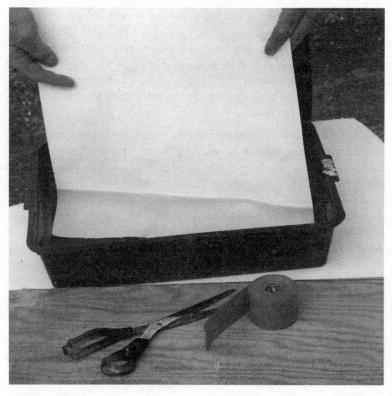

5 Soaking a sheet of watercolour paper in clean water prior to stretching

- Hold up the paper vertically to allow the surplus water to drain off before placing it on the board. See illustration 5.
- Quickly smooth it out from the centre, using a sponge.
- Also working as fast as you can, moisten each length of brown gummed paper and press it lightly in place along the edge of the watercolour paper. Start with the long sides and position the gummed paper so that half its width is on the board and half on the watercolour paper. Do not attempt to smooth out undulations, just let the gummed paper follow them. Fold the overlaps underneath the board. See illustration 6.
- Keep the board in a horizontal, flat position and allow the watercolour paper to dry naturally in a warm room. If the drying is hastened too much this can cause creasing or tears around the edges.

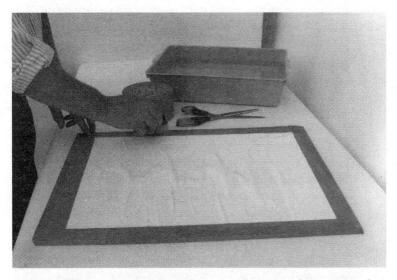

6 Stretching paper: once the wetted watercolour paper has been fixed to a drawing board by means of brown gummed-paper strips it should be left flat to dry

If it is not going to involve a lot of wetting or large areas of wash, then the paper can be 'dry' stretched: simply tape the dry paper to a board. This method is also adequate where a combination of wet and dry techniques and media is envisaged. Similarly, an alternative to the traditional method is to tape a dry sheet of paper to a board and then with the board flat, thoroughly wet the entire surface, using a sponge and plenty of water. Leave flat to dry. Also, there are products which are marketed specifically for paper stretching. These are simple and quick to use, entirely dependable and do not require any brown gummed paper. What's more, the small stretchers are an ideal size for sketching and painting outside.

Other useful materials and equipment

That well-known maxim, 'the better the artist, the more limited his palette', can also be applied to other equipment. There is absolutely no need to start with a lot of equipment, the best approach being to wait until you need a particular item or are ready to try something different before you invest in it. Look at illustration 7 and check through the list below of other useful equipment which you may need:

- Sketchbook Before you can make use of brushes, paints and paper, you need an idea. Usually, this means collecting drawings, notes and information in your sketchbook to work from. Your sketchbook is also a good place to try out design and composition alternatives and experiment with colour, techniques and materials. Look at Chapter 6 Keeping a Sketchbook for more information and advice (page 71).
- Sketching materials Use a good quality B or 2B drawing pencil to sketch in the main shapes of your painting on the watercolour paper. If you make a mistake you will find that lines drawn with these pencils will be easy to rub out with a putty eraser, providing you haven't pressed too hard. For recording ideas in your sketchbook you may like to work in a variety of media, as described in Chapter 6. A dip-pen or mapping pen used with Indian ink is ideal for ink-and-wash techniques.
- Palette Your paintbox will provide you with some mixing areas but you will probably need to supplement this with another palette when working on a large painting or one which involves a fair range of colours. Art shops have

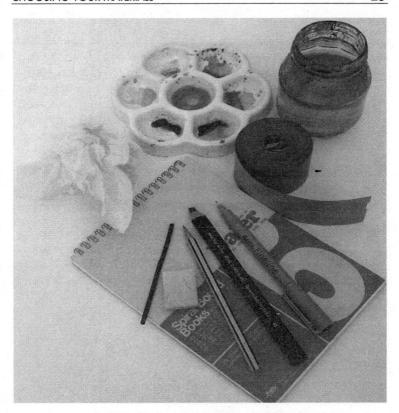

7 Various other items of useful equipment: mixing palette, water jar, brown gummed paper, tissue paper, sketchbook, charcoal, sketching pencils, fineline pen and a putty eraser

plenty to choose from. Most are made from white plastic or porcelain and they vary in size and design. You can buy tinting saucers, slant tiles, hand-held palettes and table palettes. Select, according to your needs. If, for example, you prefer to stand up and work at an easel, then a palette with a thumb-hole or thumb-ring will suit best, because you can hold this in your non-painting hand. You can, of course, also use old saucers, plates and so on. Ideally, your palette will provide a combination of small wells and deep wells so that you can mix small amounts of colour as well as generous washes.

- Water containers Old jam jars or coffee jars will do. Clean water enables pure, unsoiled colour mixes, so whenever possible have plenty of it available. Some artists use a small plastic bucket as a container. I have at least two jars of water one to rinse brushes in and the other to dip in when mixing colours and washes. When working outdoors, clean water is in more limited supply and so it is essential that any reserve amount is kept unspoilt and uncontaminated. Carry it in a screw-top jar or squeezy bottle.
- Drawing board An A2 board is recommended for indoor work, even if you use only half this size for your paintings. Prop the board up on a thick book so that it is at a shallow angle. Artists' drawing boards are expensive, but you can easily make a suitable board from an offcut or small sheet of plywood purchased at your local timber merchant or DIY store.
- Sponges, tissues and rag Small synthetic or natural soft sponges are useful for creating textures and wetting areas. You can use tissue paper to mop up surplus paint, blot and lift out colour, dab in textures and clean brushes and palettes. Soft rag will serve similar purposes.
- Masking fluid and mediums You may wish to use masking fluid to protect white areas of the painting and involve other watercolour mediums to enhance the paint flow and handling characteristics. These are explained on page 64.
- **Designers' gouache** White designers' gouache can be used to overpaint highlights and white areas or can be mixed with watercolour to create contrasting opaque passages in the painting. See page 62.
- Easel You may prefer to sit or stand at an easel to paint. There are various lightweight aluminium-frame easels which are sturdy enough to use indoors yet will fold into a compact shape for carrying around outside.

■ Outdoor equipment If landscapes and other outside themes appeal and you enjoy painting them on the spot, then you may require certain additional items of equipment. Chapter 9 Painting Outdoors has further advice and suggestions on this.

What you will need

As a summary of essential materials and equipment here is what you will need to begin with:

- Paints A paintbox, preferably of artists' quality wholepan colours, which gives a selection of not more than 10 or 12 colours. If you prefer, buy an empty paintbox and fill it with your own selection of pan or tube colours. Recommended colours are alizarin crimson, cadmium red, burnt sienna, burnt umber, cadmium yellow, raw sienna, lemon yellow, ultramarine, cerulean blue, Prussian blue, viridian and Payne's grey.
- Brushes Start with just four: a ½ in/13 mm flat for large washes, blocks of colour and dry-brush techniques; a no. 10 and a no. 4 round brush for general work; a rigger for details. Choose sable hair for the round brushes if you can afford it.
- Paper Buy an A4 90 lb/180 gsm cartridge paper sketchbook and a few large sheets of 90 lb/180 gsm cartridge paper and 140 lb/300 gsm Not watercolour paper. Try one sheet of heavier-quality rough paper, such as 300 lb/600 gsm Saunders Waterford paper, and maybe a sheet of tinted watercolour paper.
- Other equipment You will need a water jar, an old saucer or additional palette, a drawing board and some tissue paper or rag. A roll of 2 in or 50 mm brown gummed paper is needed for stretching paper and you will also require a B pencil and a putty eraser for preliminary drawing.

Project

You will be more confident about completing the initial exercises and projects, such as those concerned with colour mixing in Chapter 3, if you have already tried out your brushes, paints and paper. There's no doubt that the best way to get to know watercolour is to actually put paint to paper!

Start on a sheet of stretched cartridge paper and try the two exercises shown in illustrations 4 and 8. These will help you develop some brush control and get you thinking about mixing and applying paint. Do each exercise two or three times if you wish and don't be afraid to try other doodles and experiments to find out how the paint flows and behaves on the paper as well as how the brush feels in your hand. Try similar exercises on watercolour paper.

Use a simple exercise like this to help you practise mixing and applying flat washes of colour

3 COLOUR AND COLOUR MIXING

Colour is usually the principal means of conveying information about the subject matter and creating mood and impact in the painting, so colour is a vital quality in most paintings. Much depends on being able to mix the exact colours you require, and consequently the first essential step towards successful watercolour painting is to learn what you can about colour and gain some confidence with colour mixing.

In using colour, as in many aspects of watercolour painting, it is practice and experience that counts. Once you have become familiar with the basic theory and principles of colour mixing you will gradually begin to work quicker and the whole process will eventually seem second nature. You will soon discover that the key to success lies in keeping things simple. Colour mixes work best when just two colours are involved. The more colours you add, the more likely that the resultant mix will be dull and muddy.

Don't be alarmed if, when you start, you have a tendency to overmix colours. Whenever a particular wash or colour mix doesn't look quite right there is always a temptation to add further colours in the hope that these will do the trick and the desired colour will emerge. In fact, usually the best approach is to start afresh, but this is something we all have to learn. Remember that one of the great characteristics of watercolour is its wonderful transparency and freshness, so try to capture this quality in your work by avoiding overmixing and muddy looking colours.

A suggested maximum palette (range of colours) is listed at the end of Chapter 2. You won't need to use all of these colours in every painting, of course. Rather, you should choose those particular colours that suit the idea or subject matter you have in mind. For example, a winter land-scape will require a more subdued palette than will a subject such as a fairground scene or a vase of brightly coloured flowers. As you study

this chapter you will realise that paintings often work better when kept to a limited palette, sometimes perhaps as few as three or four main colours. Indeed, some artists would argue that you need a palette consisting of only one colour from each of the three primary groups: a red; a yellow; a blue. With intermixing, these three colours will give you quite a range to use. An additional advantage of a limited palette is that it helps to create colour harmony within the painting.

Colours have various properties. The basic quality of a true colour, that is whether it is red, green, blue and so on, rather than any tonal variations within the colour, is known as its hue. Degrees of lightness and darkness are referred to as tone and, additionally, colours have degrees of intensity. Irrespective of hue and tone, one blue, for example, might be more brilliant than another. This property is known as colour saturation or chroma.

The sequence of topics which follows will help you gain an understanding of some of the essential qualities and uses of colour. Most topics include examples and suggested exercises which will aid your understanding. Practise these for yourself and try to ensure that you are completely happy with each topic before moving on to the next. Remember that even the most experienced artists find that there is always something new to learn about colour. Keep your approach simple to begin with and gradually build on your knowledge and confidence.

Starting with primary colours

The three primary colours are red, yellow and blue and, in theory, all other colours can be created from these. However, in manufactured paints pure primaries do not exist and so, in practice, it isn't possible to mix every conceivable colour totally accurately, although we can get quite near. From the palette of 12 colours recommended at the end of Chapter 2, use cadmium red, cadmium yellow and ultramarine as your three primaries.

First, you must be aware that each of these colours has a relative strength (tone and intensity) depending on the amount by which the paint is diluted. Get to know just how much water to add by trying the exercise shown in illustration 9. This will demonstrate that you can vary the

brilliance and impact of the colour simply by adding a little less or a little more water in the mixing process.

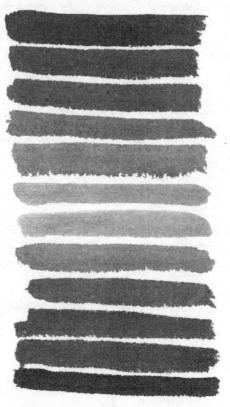

9 Different intensities of the same colour made by adding more water and then using less water

Now find out what happens when you mix one primary colour with another. When mixing, use about the same amount of each colour and aim for a paint consistency equivalent to the third stage down in the gradations of colour in the previous exercise. In turn, mix red with yellow (orange); red with blue (purple); yellow with blue (green). The three new colours – orange, purple and green – are known as secondary colours. These too can be diluted with different amounts of water to create a light to dark range. See plate 4.

When changing from one colour mix to another, first rinse your brush in some clean water and dry it on a piece of paper tissue or rag. This will prevent any contamination of the new colour. Now try mixing all three primary colours together and experimenting with other combinations, for example, red and green, or blue and purple. Additionally, it follows that the amount of each constituent colour within a colour mix will influence the resulting colour. Thus, in a red/yellow mix, more red than yellow will give a dark orange, whereas more yellow than red will produce a lighter orange.

Making a colour wheel

Copy the colour wheel in plate 3. Make your colour wheel about 6 in or 150 mm in diameter and divide it into 12 equal segments. Start with the three primary colours, which are positioned at intervals of one-third around the wheel, and then the three secondary colours, which are half-way between each of the primaries. The remaining spaces will be filled with colours which are a mixture of a primary and a secondary colour, for example, yellow and green (yellow/green) and yellow and orange (yellow/orange).

Colours which are next to each other in the colour wheel are called analogous or harmonious colours, while those opposite each other are known as complementary colours. Making use of these properties and relationships, artists juxtapose and oppose particular colours in their paintings. For example, landscape painters often include a little area of red on a figure or in flowers or on other items in order to complement and enhance any large expanses of green.

Keep your colour wheel and any other colour exercises in a sketchbook, notebook or scrapbook for further reference. Where necessary, pencil in notes to help you remember the colours and processes involved.

Matching colours

In your paintings you will be concerned with two main uses of colour: the way it can describe things and its physical qualities, such as texture. Of course, colour can be used individually and expressively, although to begin with it is most likely that you will want to paint in a

representational way and strive to match the actual colours you see in the subject.

However, copying colours isn't as easy as it looks. This is because the surface colour of something can be influenced by a number of external factors, notably light and the surrounding colours. For instance, a glass or shiny object, as shown in plate 11, will have some areas of local colour (its actual colour), plus highlights and shadows, and other parts which are influenced by reflected colour from nearby objects. Therefore, the first essential in assessing which colours to use is to observe the subject carefully and notice any variations. Look for general changes rather than subtle ones.

The basic watercolour technique is to use a sequence of superimposed washes to build up the more intense colours and darks. Consequently, a good method for the inexperienced painter is to start with a foundation wash of local colour, subsequently modifying this with successive washes to create shadows (and thereby a suggestion of three-dimensional form) and introducing any reflected colour. Seldom does the colour you want exactly correspond to any found in your paintbox and thus it has to be mixed.

First, try to identify the particular colour you want in approximate terms relative to the 12 colours in your paintbox (listed at the end of Chapter 2). If, for example, you are painting a tomato, start by mixing a wash of cadmium red. Most likely, your tomato won't be as brilliant a red as this, so you will need to add a little alizarin crimson to tone it down or perhaps even some raw sienna to make it slightly orange. Try to keep to a mixture of only two colours, otherwise there is a risk of creating 'muddy' colours. Test out your colour mixes on a piece of scrap paper first to see how they look.

When identifying and mixing colours, don't forget the exercises with primary colours and the colour wheel that you have already completed. In theory, to create shadows and darker versions of a colour, you can add a little of its complementary colour. Refer to your colour wheel. Thus, for a shadow on the red tomato you can mix a little green with the original cadmium red. If this doesn't give the exact colour you need, consider something in between the green and the red, such as purple. Remember that you can modify the strength of any colour according to

the amount of water you use. Now try the colour mixing exercises demonstrated in illustration 10 and plate 4.

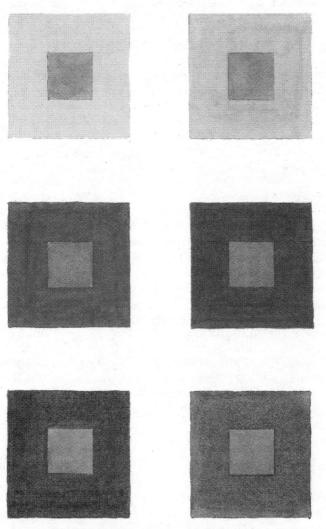

10 Experimenting with colour combinations: here, the central colour is the same but it has been surrounded with a different colour in each example – notice how the colours interact and influence one another

Colour and tone

As you have seen, in addition to their intrinsic hue, colours also have a tonal value. These variations of tone in a painting help to suggest space and three-dimensional form and can create a particular mood and atmosphere. Tonal contrasts add interest and impact.

There are two ways in which tone can be achieved in relation to colour. You can vary an individual colour from light to dark, by the relative strength of the mix (i.e. by the amount of water you use), by superimposing successive washes, or by adding another colour to it. Alternatively you can juxtapose certain colours so that they convey tonal contrasts. A pale cerulean blue, for example, is a light tone, whereas a deep orange is a mid-tone, and purple a dark tone.

In practice, as your work develops you will use both of these methods. You can model individual objects according to the lights and darks and you can create an impression of space and distance in the painting by carefully selecting the colours you need and where you place them. Distant colours are generally weak, light and subdued whereas those close to us can be strong, dark and intense. Especially in a landscape painting, this controlled use of what are known as cool and warm colours is important. So, while the background is developed in purples, blues and greens (cool colours), the detail in the foreground may contain yellows, oranges and reds.

To translate tone in terms of colour you need to be able to recognise the relative light and dark values in the subject you are painting. This will take some practice. Try to imagine the subject as a black-and-white picture. Indeed, it sometimes helps to make a small pencil or charcoal sketch first in order to sort out the main tones, see illustration 11. Another helpful tip is to half close your eyes – this gives a greater emphasis of the lights and darks. Often, tonal values need to be exaggerated in order to create an obvious sense of contrast and, consequently, impact. Try to use light shapes against dark areas and vice versa, as in illustration 12.

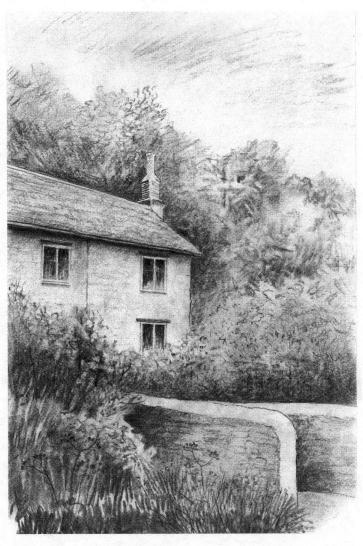

11 Tonal sketch, charcoal

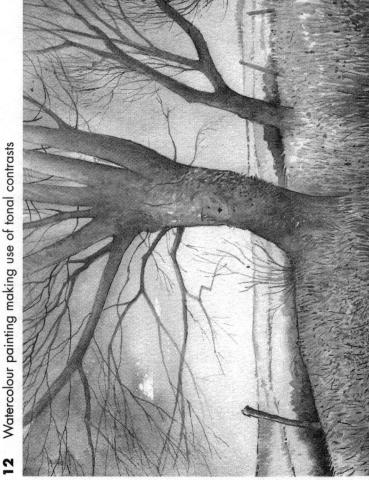

Harmony and contrasts

Another important factor to consider is the reaction which you establish between the various colours in your paintings. Colours cannot be judged in isolation; instead you have to balance the overall effect so that the picture 'reads' as you intend. Mostly you will want to create a basic harmony in the colour selection and interaction but you may need to introduce a complementary colour or more intense tone here and there, providing one or two areas of contrast and focus in order to liven up the result.

Harmony is achieved by: keeping to a restricted number of colours (a limited palette); working with analogous colours (a sequence of colours such as blues and greens on the colour wheel); or even confining the painting to one range of pigments, say reds. The degree of contrast or counterpoint necessary will vary from one idea to another. In a land-scape, for example, a contrasting colour might be introduced in a foreground detail, while in a portrait the flesh tints themselves may provide enough contrast to the clothing and background.

When you begin to experiment further you will notice that even a small amount of some colours can dominate a painting when used in conjunction with certain other colours. This is because each colour has a different 'key' or intensity. For example, it would take a large area of green to balance just a tiny amount of red. Similarly, colours can be heightened or subdued by whatever colour is placed next to them or around them. You will begin to understand this better when you have tried the exercises at the end of this chapter.

Sometimes paintings are described as having a high key or a low key. This refers to the general effect of the combined colour and tonal values in the work. If the painting involves bright colours and light tones it is said to be high key, while contrastingly, if it uses mainly subdued colours and dark tones it is low key. Look at the different effects conveyed through colour in plates 1, 2, 6, 8, 11 and 12.

Expressive colour

You may find that some ideas and subjects inspire a much more personal response to colour: it can be used subjectively as well as in a representational manner. Perhaps, in order to convey a particular mood or feeling in a painting, you will need to emphasise certain colours while underplaying others. In the same way, colour can be used to dramatise an idea or enliven a seemingly ordinary subject such as a still life. So, don't be afraid to use colour boldly and with a subjective judgement if you feel this will aid your interpretation of the subject and create a more interesting result.

Projects

- 1 Complete the exercises described in illustration 9 and plate 3 in relation to primary colours and the colour wheel.
- 2 Look at the colours in your paintbox (see end of Chapter 2 for a list of recommended colours). On a sheet of A4 paper paint a small square of each colour in sequence, placing them in **tonal** order, that is from light to dark.
- 3 Try a small, simple landscape similar to that in illustration 13 in which colour is used tonally to give an impression of distance.
- 4 You will notice that your colour wheel does not include any browns or blacks. A mixture of all three primary colours will create a brown, but how else could you mix a brown? Also experiment with ways of mixing a really dark colour that could be used instead of black.
- 5 Look at illustration 10. Here, the central colour is the same but it has been surrounded by six different colours. Note how the interaction of each combination of colours produces a different visual effect. Try similar experiments using other colour combinations, some with analogous colours and some with complementary colours.
- 6 Look at illustrations 11 and 12. Now try painting two watercolours of the same subject. In the first interpret the subject in monochrome, that is using one colour and concentrating on tones, and in the second treat it realistically, in terms of the colours you see.

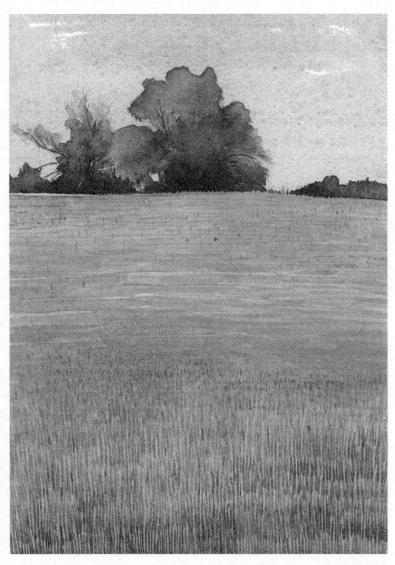

13 A simple landscape showing how depth can be suggested by giving greater emphasis in colour and technique to the foreground

4 LEARNING THE BASIC TECHNIQUES

From your work in Chapter 3 you will have gained some confidence with mixing paint and applying it in various ways. I expect you have discovered that the size and type of brush you choose, as well as how you control it, markedly influence the sort of effects you can achieve. Building on this experience you can now try out all the basic watercolour techniques. This will give you a good range of painting skills from which to start developing your work with real confidence.

Later, in Part 2 of this book, you will be encouraged to tackle specific projects and subjects. A knowledge of different techniques will mean that you can choose the most suitable method for the subject matter and the particular effects required. Now work through the techniques described on the following pages and practise them as much as necessary. If you are not happy with your first attempts, then try again. Don't worry about wasting time or using a lot of paper. All the exercises and practice pieces you do will help you to develop your skills and understanding. Keep all of this practical work in a folder for future reference.

Most artists have one or two favourite techniques and, as you begin to work with greater confidence, you will enjoy improvising from the basic methods and inventing some of your own. For, as we have already seen, there is no fixed way of painting in watercolours. Often the technique is intrinsically linked with the type of paper used and, in some cases, the particular brushes and other equipment. If you need to, have another look through the information about paper in Chapter 2. Take note of any recommendations concerning paper which are mentioned in the following text.

Mixing and applying a wash

The ability to mix, lay in, and manipulate washes is fundamental to most watercolour paintings. Wash is thin, well-diluted paint and it is made by

mixing a little pigment (paint colour) with plenty of clean water. It is the basic technique of traditional watercolours, where, working from the palest areas, a succession of thin, superimposed washes is used to gradually build up stronger and darker tones. Most other techniques, as you will see, rely on working over or into an area of wash.

In general, washes are used for large background areas such as skies, but they can be of a more limited and controlled variety. Some artists start by applying a wash to the whole paper, while others use a sequence of confined washes.

Your first practice exercises could be on sheets of stretched 90 lb/185 gsm cartridge paper. The technique used to stretch paper is described in Chapter 2. Study the text below and the sequence of exercises shown in illustrations 14 to 17. Start by making a flat wash (illustration 14) and then move on to try a gradated wash (illustration 15), working on dampened paper (illustration 16), and a wet-in-wet wash (illustration 17). When you feel happy about these different wash techniques try them on heavier-quality watercolour paper (140 lb/300 gsm).

Work your initial exercises so that each covers an area about A5 size, but try a few larger areas later. Mix plenty of paint. One of the worst things

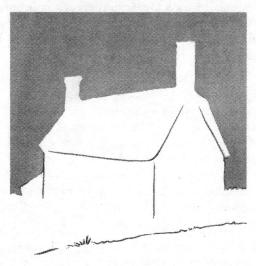

14 Flat wash

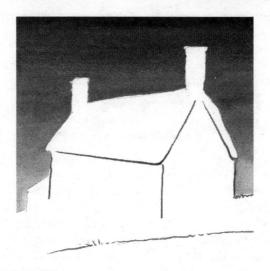

15 Gradated wash

to happen when applying a wash is to run out of paint! Always mix more wash than you think you need. Remember that the colour has to be weak and watery so that it is easy to manipulate, isn't absorbed quickly into the paper, and doesn't dry too quickly. You need a tint or stain of colour, not too weak, but diluted enough so that it is translucent when brushed across the paper.

Any colour will do for these practice exercises. You can keep to simple, rectangular areas of colour or try applying a wash up to a silhouetted shape, as in illustrations 14 to 17. Mix your wash in a small pot or similar container. First, fill it with about 1 cm of clean water, then add the pigment, little by little. Dip your brush in the wash and test the colour on some scrap paper. Let it dry so that you can check exactly the strength of colour. Remember that watercolour tends to get lighter as it dries. If the wash is too weak and runny, add more pigment, and if it is too strong, add more water.

The general principle in watercolour is to use the largest brush possible, and this is especially true when applying washes. You can use a large (1 in/25 mm), flat one-stroke wash brush, a hake, a no. 10 or larger round

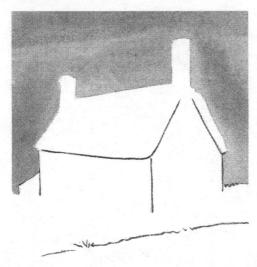

16 Wash applied to damp paper

sable, or even a household decorating brush. You will probably find that flat brushes work better than round ones in helping to create an even wash. On the other hand, sometimes a patchier effect is what you want.

Your painting paper should be firmly fixed to a board which is tilted at a slight angle: prop it up on an old book. Work from the top to the bottom of the wash area, applying the colour from a full brush with confident, flowing strokes from one side of the paper to the other. Work as quickly as you can: the wash should always be applied against a wet edge. Surplus wash may collect at the bottom of your paper and you can lift this off with a dry brush or some tissue paper.

You should be able to produce a wash which is completely even, with no drips of colour or 'tide marks' where it has dried unevenly. Such a neat finish is not always necessary, however. Now try a wash effect like the one in illustration 15 which starts quite light and gradually gets stronger in colour. Adopt the same method except add a little more pigment with successive brush strokes as you work towards the darkest area. If it helps, turn the paper upside-down so that you can work from light to dark down the paper.

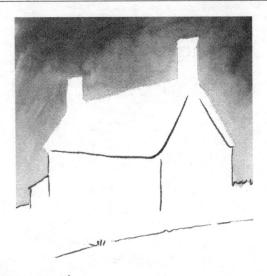

17 Wet-in-wet wash

An alternative gradated technique is to apply three different strengths of one colour or three different colours and then quickly blend them together by working down the paper with a large brush dipped in clean water. Also, try laying-in a wash on paper which has been dampened slightly with a sponge, as in illustration 16, and try blending a variety of tones or colours together, wet against wet, as in illustration 17.

You will soon notice that the great thing about making successful washes is that you must have everything ready and you need to work quickly and confidently. Now look at the exercise in illustration 18 and practise painting wash over wash to achieve various strengths and colours. This is the way you will build up contrasting tones in actual watercolour paintings later on.

If you need to cover really large areas with an even wash, try using a household decorator's brush, a shaving brush or a hake brush. The larger the brush, the less likely it is that your painted wash area will be spoiled by brush marks or streaking. Make sure you load the brush evenly with colour before applying the wash, and work quickly.

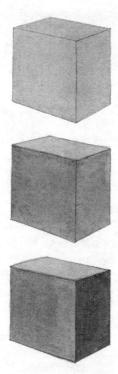

18 Using a sequence of superimposed washes to suggest three-dimensional form

Different wash effects

The flat wash is the one most frequently used by artists but alternative types are sometimes chosen to add interesting effects to certain parts of a painting. Here are four more wash techniques which you may like to try out:

■ Variegated wash Use several colours in either a deliberate or random way, allowing them to bleed or fuse into each other. This method usually works best on slightly damp paper. You could paint a sunset sky using this technique, for example, or suggest reflections in water.

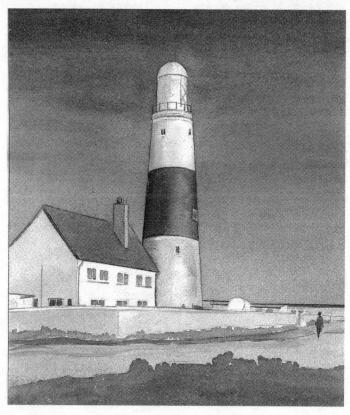

- 19 A painting made with a number of different wash techniques
 - Using textured paper If you paint a wash on heavyquality paper some of the 'tooth' or the tips of the textured surface will show through as white specks. This is an effect which can be used to advantage in painting a seascape, for example, or a similar subject which includes flecks of light or a comparable texture. Use a rough watercolour paper, preferably 300 lb/600 gsm.
 - Wet paper By dampening your paper first, using a sponge and clean water, you can create a softer, diffused wash effect.

■ Granulation Some pigments have a tendency to separate from water when used in a wash. This causes a slight break up in the surface appearance of the wash – a sort of faint cracking. Again, this is a characteristic which can be exploited where you require a solid area of colour, but with a slightly grained or textured effect. You will need to experiment to see which colours work best and what proportion of water to use. Colours that have this characteristic include ultramarine and cerulean blue, burnt umber, raw umber and yellow ochre. Bear in mind that pigments do vary from one manufacturer to the next.

Later you will see that it is possible to work into and over washes in different ways, but for now try just one of these techniques. While your wash is still wet, dab into it with a screwed up piece of tissue paper, a soft cloth or a sponge to experiment with 'lifting-out' effects – that is removing some of the wet wash. This can also be done with a dry brush. In a landscape painting, for example, having blocked in the sky with a blue wash, you could then use this method to lift out some clouds. It is also a good way to create texture, by dabbing into wet paint.

Try putting a variety of wash techniques into practice by doing a small painting like illustration 19. Here, the sky is a manipulated gradated wash with some lifted-out areas, as described above. For most other areas I have used flat washes of colour, except on the lighthouse, where I have combined both lifting out and superimposed washes in order to give a three-dimensional effect.

To perfect a gradated wash, work over the completed wash with a large, flat brush dipped in clean water. Use single, broad brush strokes across the paper, pressing only very lightly. The brush should be damp rather than wet.

If your variegated washes appear muddy in colour, it is probably because you are working too quickly, causing the wet colours to bleed into each other too much. To overcome this, pause for a minute before applying each new colour. Paint in your first colour and let it start to dry before adding the next.

Line and wash

Line and wash is an interesting combination of drawing and painting techniques which dates back to the topographical watercolour drawings made by artists in the eighteenth century. The line (drawing) provides the structure and most of the information of the picture, while the wash (colour) adds unity, colour and mood. See illustration 20.

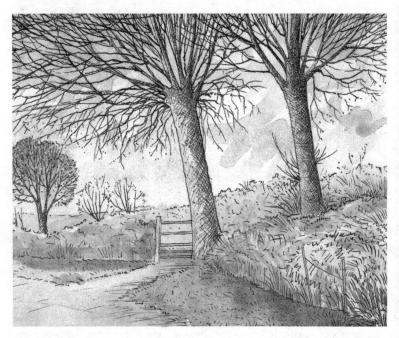

20 Ink and wash

Pen and ink is a good drawing technique to use. You can choose from a great variety of pens, including dip pens with Indian ink or coloured drawing inks; art pens, technical pens and other refillable pens; inexpensive fineline fibre pens and markers. You must ensure that the ink you use is permanent or waterproof, so test the pen on a piece of scrap paper first. Draw a few lines, let them dry, and then wet them with a brush and some water. If they dissolve and blur, you must find a different pen! Strong pencil drawing also works well. You can try other

drawing media, but you will find that some blur quite badly when the wash is applied. Sometimes you can make deliberate use of this effect where you need vague, atmospheric impressions rather than well-defined drawings.

Try two methods of approach. You can either make the drawing first and then tint this with a few thin transparent washes of colour, or you can start with one or two basic washes to establish the main tones, adding lines and details over these with a pen or pencil. Line and wash is especially good for quick sketches and small, delicate subjects such as flowers. See also Chapter 6, *Keeping a Sketchbook*, and illustration 33.

Painting wet-in-wet

Loosely painted watercolours are sometimes described as 'controlled accidents', and this certainly applies to the wet-in-wet method. This technique is a natural progression from using washes and is a great way to create impressions, mood and atmosphere. Here is a technique which will really let some personality shine through – an essential skill for the watercolourist.

With wet-in-wet, colour is applied to damp or wet paper or into or against other colours while they are still wet. Consequently, there is an exciting fusion of colour and the artist never quite knows what to expect – the work is always just slightly out of control.

Wet-in-wet works well on Not papers (see Chapter 2), that is those papers which have a medium-textured surface. But you may like to start with some experiments on stretched cartridge paper until you feel confident with the technique. Whatever paper you choose, as it will be used in a wet state, perhaps extremely wet, it should be stretched first (see Chapter 2). Only the heaviest quality papers, say 200 lb/410 gsm and above, can be used without first being prepared in this way.

Have your washes and equipment ready and start with some exercises using just two colours, like the sequence of effects shown in illustration 21. Work with your board at a slight angle. Keep the paper slightly damp by using a sponge dipped in clean water. Mix the washes to a stronger consistency than usual, as they will be further diluted when applied to the wet paper. See also illustration 22 and plate 8.

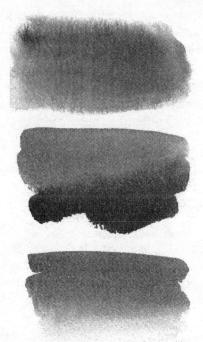

21 Wet-in-wet techniques: (top) applying wash to damp paper; (centre) working one wet colour against another; (bottom) fading the edge of a wash by blotting it with tissue paper

The basic wet-in-wet techniques are as follows:

- Single wash Apply the paint to an area of dampened paper and allow to dry. Note that this sort of wash produces a diffused, more atmospheric effect than one applied to dry paper. See illustration 21 (top).
- Blending edge to edge Working on damp paper, run one colour against a contrasting one so that the edges bleed into each other. See illustration 21 (centre).
- Fading colour Apply the wash to slightly dampened paper and, while it is still wet, blot along one edge with tissue paper. See illustration 21 (bottom).

You can also allow colours to fuse and intermix by dabbing a second colour into a wet wash.

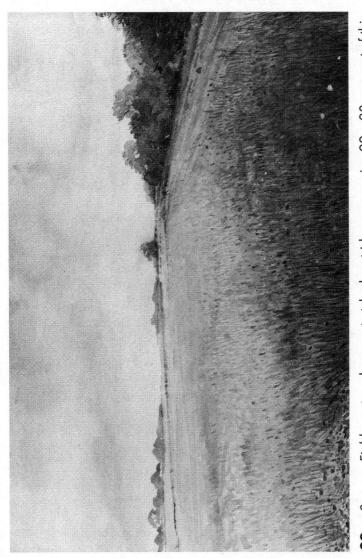

Summer Fields, watercolour on stretched cartridge paper, size 22×28 cm: most of this painting is built up with wet-in-wet washes of colour

An entire painting can be developed as wet-in-wet, especially if a limited palette (range of colours) is used, as in plate 8. Here, I used only three colours: Hooker's green deep, raw sienna and cobalt blue. For the weak sky effect various strengths of cobalt were worked over a wet base, fusing into raw sienna near the horizon. Most of the foreground uses strengths of Hooker's green and raw sienna applied wet-in-wet. The trees were painted with drier pigment while the background was still wet, in order to create softer outlines.

You can also use wet-in-wet in a more controlled way on lines and edges. Try these ideas:

- Draw a line with your brush and let it dry. Now wet this with a brush loaded with plenty of clean water. Blot it with some tissue paper to reduce the colour and soften the edges.
- Wet the edge of an area of dry colour with a no. 10 brush dipped in clean water. Use a dry brush to lift out some of the paint and blend out the edge.
- Dab into an area of dry colour with a stiff-haired hog brush loaded with clean water, in order to loosen the paint. Now use a tissue or dry brush to lift and remove the paint and thereby create a highlight area.

Wet-on-dry

Usually, to achieve a sense of space and three-dimensional form in a watercolour it is necessary to involve a range of tonal (light and dark) as well as colour effects. The play of light influences most painting subjects and therefore the artist must capture the significant highlights and shadows in order to create a convincing painting. Colour, too, will vary. Generally speaking, distant colours are weak and foreground colours are much stronger and more obvious.

The principal way of making darker and richer colour areas in a water-colour painting is to use a sequence of superimposed washes; that is, to paint one wash over another until the required depth or brilliance of colour is achieved. Before each new layer of colour is applied, the existing paint must be completely dry, otherwise the fresh colour will intermix with or even lift out what is already there. This method is known as working wet-on-dry.

In effect, wet-on-dry is a sort of glazing technique. With this method you have to be careful that you don't overwork the painting. The more layers of paint you put on, the greater is the risk that the colour will become muddy and lose its vigour. Where you need a really strong colour in the picture, it's best to make the initial wash quite positive.

When applying a further wash over dry colour, paint it on with broad, flat strokes. Use the largest brush you can confidently manage and, like any wash, work from side to side across the area with continuous brush-strokes. Hold the brush at an acute angle, almost horizontally. On no account should you scrub into the paint surface.

Painting wet-on-dry gives a more controlled paint flow and greater clarity and definition where required, as in plate 10. An alternative way of using this technique is to paint *alla prima*, that is to work on dry paper with a single application of paint, varying the strength of colours from the outset, as appropriate to particular shapes and areas. *Alla prima* usually relies more on brushwork than on flat areas of wash, although obviously brushes of different sizes will give contrasting effects.

This is a good method to use when time is limited and you want to create a quick overall impression of a subject. It is unhindered by the delays which can occur with other techniques, where you have to wait for an area of wash to dry before you can proceed. See plate 7.

Dry-brush

This technique is ideal for creating texture or broken colour, or for exploiting the textural qualities of thick, coarse paper. The type of brush also plays its part. As the name implies, this method involves using a brush with the minimum of paint on it. When the brush is lightly dragged across a sheet of medium- or heavily textured watercolour paper it catches the surface here and there and so creates a patchy, broken area of colour.

Similarly, using a flat, stiff-haired hog brush with fairly dry paint you can suggest the texture of grass, foliage, hair and so on, as in illustration 23.

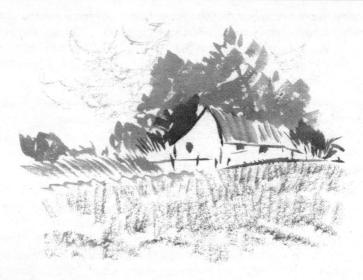

23 Dry-brush texture

Like all techniques, practice will help you develop the necessary confidence and skill. Dry-brush needs just the right amount of paint: if there is too little paint then the effect is negligible, while if there is too much you will make an uneven wash.

Try these exercises to see what possibilities there are for dry-brush effects:

■ Use a stiff-haired hog brush with just a little paint. Drag it lightly across some cartridge paper, then across some heavy-quality watercolour paper. Notice how the paper influences the result. Experiment with holding the brush in various ways and using different amounts of paint. You can build up a texture by dragging the brush first in one direction then working over this in the opposite direction, perhaps using another colour. Try these two ways of loading the brush with paint: dip the brush in water, then wipe it almost dry before picking up some undiluted pigment; load the brush with mixed colour in the normal way, then dry it with some tissue so that very little paint is left.

- Try the same exercise but this time using any other brushes you may have a round watercolour brush, a flat-wash brush, a fan brush, and so on.
- Use a stiff-haired hog brush dipped in a little paint to create a stipple effect. Hold the brush vertically and gently stab it up and down to give a sort of dotted texture.

You will find that with dry-brush methods the paint just catches the tooth of the paper, so creating a textured result, with some parts left white. You can use this technique to work over washes to suggest foliage, stonework, reflections and other surface effects.

Creating whites

This is one of the most difficult aspects of watercolour, certainly for those new to the medium. With a technique that relies essentially on superimposed broad washes of colour, how can you convincingly convey those tricky little white shapes, highlights, areas of reflected light, and so on? Irrespective of any local colour or obvious lights in the subject, watercolourists often like to introduce a dash of white somewhere to add a bit of punch and contrast to the work.

You can create whites in the following ways:

- leave specific parts of the paper white
- use masking fluid
- wet and lift out colour
- scratch through the surface colour with a sharp point
- use white gouache.

Reserved whites If the paper is going to be left as a white area, then obviously the work must be carefully planned from the outset so that any whites are specified as parts of the initial design or drawing. With an individual subject white areas can usually be memorised, but in a larger and more complex watercolour they might need to be indicated in some way or drawn in as specific shapes. Where a white shape needs precise definition, for example the side of a house or a white gate, then it is best to draw this in and perhaps even lightly pencil 'white' across it just to remind you not to engulf it in an enthusiastic wash!

Masking fluid For well-defined shapes, precise lines, distinct edges and small flecks or details of white you could use masking fluid. This is a rubber compound solution which is painted on to particular areas to prevent them from accepting paint. Paint it on in the appropriate places using an old soft-haired brush or dip pen. Don't use your best brushes as they will be difficult to clean properly. When the fluid has dried you can paint a wash right over it – therefore it overcomes the difficulty of painting exactly round a shape or remembering where to leave a white gap. When the wash is dry you can rub off, or peel away, the rubbery solution to reveal a well-preserved white shape. Because it leaves quite a positive edge, masking fluid is not ideal for some highlights and white shapes, although you can wet and blend the surrounding colour to disguise any obvious boundary. See illustration 47.

Lifting out If you have forgotten to put in a white or decide that you need a highlight somewhere, then you can wet the particular area with a brush and clean water and lift out the paint. First, work into the wash with a stiff-haired brush, being careful not to damage the paper surface too much. Then use a dry brush or some tissue to soak up the disrupted paint. The success of the lifting-out technique will depend to some extent on the type of paper and paint which has been used. Some colours have a greater staining power than others, just as some papers are more absorbent than others. Often it is impossible to remove all the colour from the paper and therefore the white is subdued rather than brilliant.

Scratching through Small marks and broken white areas can be created by scratching into the dried paint surface with a sharp knife. This works best where both the paint and the paper are quite thick. It is a good method to use for a highlighted edge or outline, or the glints of light on the surface of water, for example. See illustration **24**.

White gouache Sometimes it is extremely difficult to leave just a small area white, masking fluid is unsuitable, and sheer forgetfulness has meant that a vital white part has been painted over. The colour, paper and effect required may mean that the wet-and-lift method will prove equally unsuccessful. In this case the only alternative is to use white paint. In some situations Chinese white watercolour is ideal, because this can be softened and blended around the edges. For a more intense white, and one which has to cover strong colour beneath, you will need

24 Scratching through colour with a sharp knife to create highlights

to use designers' white gouache. Sometimes more than one application is required to create a really brilliant white. Use the paint in a fairly thick consistency and lay it on carefully, in order to avoid any intermixing. Blend it round the edges, if necessary. See plate 11.

Gouache is not used in traditional watercolour painting, of course, although there are many great watercolourists, including Sandby, Turner and Palmer, who have found that it can play a perfectly valid and acceptable part in the painting process. There are no hard-and- fast rules about watercolour and, like everything in painting, the use of gouache is a matter of personal choice. If it suits your method of working and doesn't look out of place in the painting, then why not use it?

Because it is not possible to mix a new wash to exactly the same strength as a previous wash, you should always mix more paint than you think you will need. When applying a flat wash avoid going back over any brushmarks as this is likely to lift the paint or cause streaking.

You may speed up the drying of a wash by using an electric hairdryer. However, don't hold the dryer too close to the painting or concentrate the heat in any one place.

Whenever possible, use, old, well-worn brushes to apply masking fluid. Protect any brush you do use by first coating it in some liquid soap. This won't have any effect on the masking fluid, but will make cleaning the brush much easier

Projects

- 1 Collect together all of your exercises and experiments from this chapter. Label each with a brief note or reference description. File them in a scrapbook or folder for future reference. Postcards, cuttings and other ideas can also be kept in your scrapbook.
- 2 Set up a simple still-life group which includes some bold, contrasting shapes, like the one shown in plate 11. Include at least one object which has a highlight or white area. Working on a sheet of A3 stretched cartridge paper, make a line-and-wash study of the group. Next, choose a different viewpoint and, working from a preliminary faint outline drawing on a sheet of 140 lb/300 gsm watercolour paper, use a series of washes to build up the necessary shapes and strengths of colour. Look particularly at shadows and tonal contrasts.
- 3 Take as your subject a view from a window. Choose a view which isn't too complicated and which has some sky area. Work on A3 paper or larger. Sketch in the main composition. Use a wash sky effect, with parts lifted out and worked into. Complete the painting by using any watercolour technique or combination of techniques. Refer to the techniques described in this chapter and try to choose those which are appropriate to the effects you require. Make a contrast between the foreground shapes, with their greater emphasis and detail, and the distance.

PROGRESSING TO ADVANCED TECHNIQUES

Typically, the success and impact of a watercolour relies on its use of colour, transparency and atmosphere as wash is the principal technique used to create these qualities. However, not every surface is best portrayed by washes of colour. There will be times when you will want to include other effects, such as opaque colour and particular surface details and textures. Additionally, these effects will create areas of contrast and interest in your paintings.

Before trying out the more advanced techniques described below, do ensure that you are happy and confident with the basic methods covered in Chapter 4. Whatever style or approach you eventually adopt, techniques such as wash and wet-in-wet will be fundamental to your work.

Making textures

Unlike oil painting, acrylic and various other media we do not associate watercolour with surface painterly qualities and textures. Yet, if you are painting a lichen-clad old stone wall, a heavily grained wooden door or a mass of tall, windswept grasses, how do you suggest their individual character and texture? Watercolour can be more versatile than we are lead to believe and there are various ways that such textures can be implied if not actually created. However, texture is something to use selectively. While there are artists whose paintings rely almost exclusively on techniques such as wax resist and dry-brush work, my advice is to avoid the temptation to indulge in a lot of exciting textures. Introduce them here and there, where they are appropriate to the subject matter and will liven up an area and, in consequence, perhaps enhance the whole painting.

Here are various texture methods which you can try out for yourself. Experiment on offcuts and scraps of paper of different types.

- Dry-brush and Stipple You have already come across these in Chapter 4. Have another look (pages 53–5).
- Spattering Dip an old toothbrush or stiff-haired brush into some paint, hold it directly in front of the part of the painting you wish to treat and pull back the bristles with your forefinger to create a shower of fine spray. You can build up layers of speckled texture in this way and the spray can be confined to a specific shape or area by masking out the surrounding parts with paper.
- Wax resist This creates areas of broken colour, with the paint drying in small globules over the undercoating of wax. First, coat the paper with a layer of wax, shading it with an ordinary wax candle or a wax crayon of the appropriate colour. Apply a fairly thick wash over this and allow to dry. The wax can be applied to plain paper or over a painted area. Wax resist is used in the foreground area of plate 11.
- Scratching-out Scratched-out lines are more subdued than those resulting from masking fluid and are a good method to use when you want to create subtle highlights or give the impression of foreground grasses or similar textures and details. The timing has to be just right: the paper should be slightly damp. Use a razor blade or sharp craft knife to scratch through the surface paint to reveal the white surface of the paper underneath. Apply just sufficient pressure, so that the paper surface isn't unduly damaged. In fact, it is unlikely that you will get a true sharp white line or highlight this way, for the watercolour will have stained into the paper surface, hence the lines are subtle.

If necessary, you can use the craft knife against a straightedge to make perfectly straight and well-defined lines. You can also use this technique on a painting that has completely dried. Brush across the area once with clean water, than scratch through.

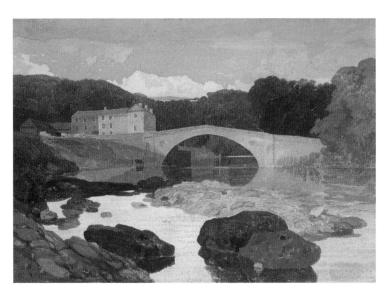

Plate 1 Greta Bridge by John Sell Cotman © The British Museum

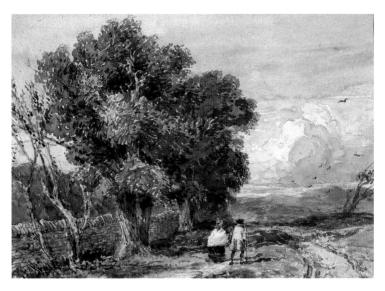

Plate 2 A Windy Day by David Cox, Williamson Art Gallery & Museum, Birkenhead

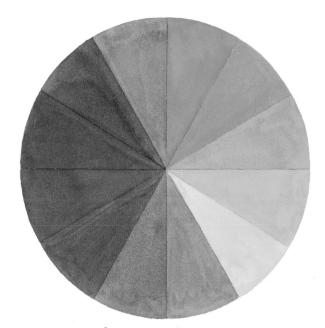

Plate 3 Colour wheel

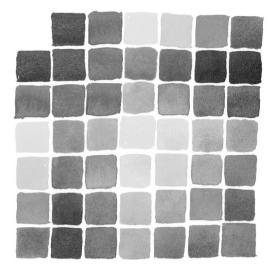

Plate 4 Mixing primary colours

Plate 5 Charcoal-watercolour sketch

Plate 6 Melbury Reservoir, watercolour painting made from the location sketch shown in illustration 1, size 16 x 26 cm

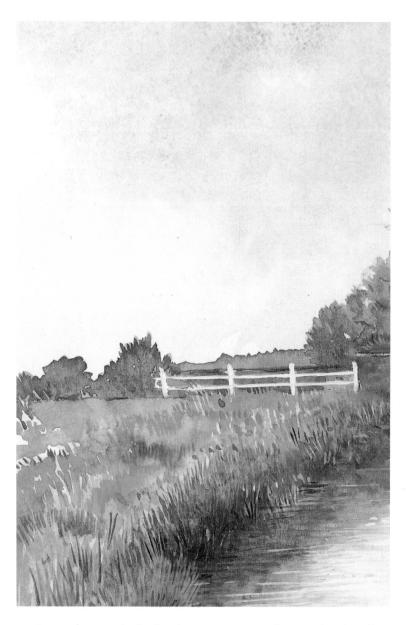

Plate 7 Detail of a landscape painting, showing brushwork

- Cutting-out This is a similar technique for making fine white lines, but this time it actually involves removing the surface layer of paper. Use a sharp scalpel and a ruler, ensuring that you cut only the surface of the paper. Cut two parallel lines close together and then carefully peel away the paper surface in between.
- Dabbing You can use this technique to create textures such as foliage. Use a screwed-up piece of tissue paper dipped in fairly thick paint and dab the area repeatedly to build up the required texture. You could use more than one colour to give a blended, textural effect.
- **Sponging** Natural and synthetic sponges can be used to apply washes and dab, stipple or lift out areas of colour.
- Eraser A plastic eraser probably works best, although most types can be used to lift out highlights, lighten areas or soften edges. Make sure that the painting is completely dry first. For straight lines, use the eraser against a ruler. An eraser can also be used with other texture techniques. For example, an eraser-and-scalpel combination is effective for suggesting the highlights on water. Scratch the surface of the paper with the scalpel and then dab the area with an eraser to remove the necessary amount of colour.
- Split-brush Use an old brush, preferably a Japanese bamboo brush or similar, which is not too soft and so allows the hairs to splay out. Dip it in just a little paint and, holding it vertically, push it down on the paper. This will give a broken brushwork effect and is another good method for foliage as well as for blending out the edges of clouds and other shapes.
- Salt Use salt where you want a light, dotted texture. You can use fine table salt or sea salt. Sprinkle it over the wet paint where you want to suggest surfaces which have a soft speckled appearance, such as rust, frost-covered glass, or tree tops in a distant forest. When the painting is dry, brush the salt off.
- Paper Don't forget that the paper surface produces different texture effects when weak washes, dry-brush and other techniques are applied over it. (Illustrations 25 and 26.)

25 Using various textures, including spattering (background), dry-brush (base area), and stippling, scratching out, gouache and other techniques on the bird

Opaque effects

Occasionally the subject matter needs a contrast between translucent washes of colour and more solid, opaque areas. Although it is possible to build up dense colour with a succession of washes, many artists prefer to combine watercolour pigment with gouache in order to extend the range of effects and handling possibilities.

Gouache is made in a similar way to transparent watercolour except that it has extra glycerine to make the paint film thicker and more flexible. Gouache colours are less brilliant than true watercolour but they do flow and brush out well, especially for flat areas of solid colour. Like watercolour, they can easily be re-wetted and consequently reworked or blended. Gouache is also good for dry-brush work and for superimposed whites. You may wish to supplement your watercolour palette with a few tubes of gouache.

In plate 11 I have used watercolour and gouache techniques. Gouache can be helpful, but if it is overdone the painting loses its transparency and the colours become muddy and overworked.

Working on heavy-quality paper with masking fluid, wax resist and other techniques to create various textures

Masking fluid and mediums

In Chapter 4 you learnt how masking fluid can be used to preserve white areas in a painting. Although it is usually painted in at the beginning of the work, masking fluid can be used at any stage to protect an area or colour from subsequent washes.

Also available are other mediums which can be added to watercolour to alter the consistency of the paint, to enhance the colour or to add texture. As you do more watercolour painting you may wish to experiment with these mediums and check for yourself their potential for different effects.

- Watercolour medium This is a transparent medium which helps to bind colours and improve the paint flow. You can also apply it to wet colour to create texture.
- Ox gall liquid You can buy this in liquid or pan form. Ox gall is a wetting agent which causes the pigment to flow away from the point of application. It is an effective technique for suggesting rounded surfaces like a car tyre or the side of a jar.
- Gum arabic If you mix a little liquid gum arabic to your water when painting, it will give the colour more body (a thicker consistency) and make it easier to control and blend. Also, heavily diluted with water, gum arabic can be applied as a sort of varnish to an area of the painting that may have dried rather dull and uninteresting.
- Texture medium This is sold under various trade names, such as Winsor & Newton's Aquapasto. It is a transparent gel medium which can be mixed with watercolour to create a thicker consistency of paint. Use it when you want to apply an obvious textural finish to a certain area or you wish to scratch into the painted surface.

Combining techniques

You will soon realise that there are many techniques to choose from and that occasionally you might need to combine several methods and effects in the same picture. Sometimes, a single technique won't be adaptable enough to produce the variety of paint qualities that you need in order to create a convincing impression of the subject matter. Therefore, in addition to the basic washes of colour, you may need to use some contrasting opaque areas, texture, dry-brush work, and so on. Combining techniques in this way does more than enable a greater sense of realism in the painting, it also adds to the visual interest of the work and its overall impact.

Selecting the right technique for a certain subject, surface or effect is, of course, something which will develop with experience. Similarly, the skill of combining techniques comes through practice and the willingness to try things out. Don't be afraid to take risks and to experiment in your paintings. This is what painting is all about – exploring new ideas and discovering fresh techniques and approaches. Although not every picture will work out exactly as you would like, any mistakes will prove very instructive. There will no doubt be some methods which you will especially like and which you will want to pursue and develop in your own way. It is only by practising all the basic techniques that you will be able to choose wisely those which suit you best and which are most appropriate for the sort of subjects you enjoy painting.

In this context I should like to make one or two observations about style. Often, artists are too anxious to create a style of their own. However, style isn't something you can copy or develop overnight. Give it time! Style evolves gradually and your individual method of painting will grow from the sort of subjects you paint, the techniques which interest you, and your special way of looking and interpreting. Be inquisitive, and find out all you can about methods, subjects, how other people paint, and so on. Paint as often as you can. Your style will develop from this strong base of knowledge and experience.

27 Combining techniques

Once you have gained some confidence with individual watercolour techniques you will want to experiment with combining different methods. You have already seen that techniques like line and wash, and resist and wash go well together. These ideas can be extended so that you might, for example, use a combination of resist, wet-in-wet, lifting out, and line and wash. In the same way, some drawing media work well over washes of watercolour – pencils, inks, pastels and charcoal, for example. Try these out in your sketchbook. In illustration 27, I have used mostly fairly dry and controlled dots and dashes of colour over the initial washes in a kind of impressionist technique. Dry-brush and gouache are other techniques used in this painting. In illustration 28, watercolour washes have been combined with pen and ink (the silhouetted trees) and pastel (the fields beyond) in this mixed media painting. The foreground is a combination of watercolour brush strokes and pen and ink lines.

Correcting mistakes

One of the great characteristics of watercolour is that you can never be absolutely sure about how it is going to behave. Also, there are all sorts of factors which can influence its behaviour, such as the type of paper you are using, the ambient humidity and the consistency of your colour mixes.

If you are having problems with the way that the paint is responding or drying, then check through the list below. This identifies some of the common problem areas and advises how to put things right.

- Weak colour Wet colour is deceptive. Remember that watercolour always dries a lot lighter than it looks when initially applied to the paper. If, when dry, your colours look disappointingly weak and washed out, then you need to add more pigment, or less water, when you are mixing them.
- Adding water If you find that you normally add too much water to the pigment when making a colour mix, try using a pipette (dropper). This will allow you to add just a little water at a time and so avoid 'flooding' the colour.
- Backruns If you apply paint next to an area which isn't completely dry, the new colour will bleed or fuse into the surrounding area, something which is known as backruns. Where you want crisp, well-defined shapes and lines ensure that the painting is dry before adding fresh paint.

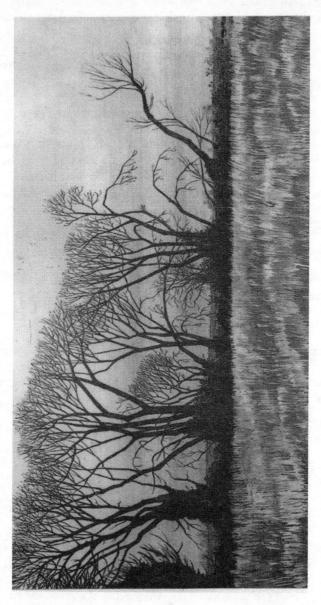

- Muddy colours Try to keep your paintings looking fresh and light. If the colours look dull and muddy then you may be working too quickly. Don't overdo wet-in-wet techniques; avoid building up too many layers of colour. Keep to a limited palette (range of colours) as much as possible. Allow some of the white paper to shine through in places.
- Dull pictures There may be various reasons why a painting looks dull and uninteresting. For example, it could be the subject matter itself, or the composition. Most likely it is because the painting lacks contrast, particularly in tone. You can contrast weak washes of general background colour with stronger colours and detail in the foreground, and highlights with a few areas of deep shadow.
- Blending Especially if you work slowly, you may find it difficult to create soft, blended edges to shapes. Ideally, blended colours need to be laid in on damp paper, putting in the lighter tone first. However, you can soften hard, dried edges of colour by brushing across them once with a flat, soft wash brush dipped in some clean water. Leave to dry and repeat the process if the blending isn't sufficient.
- Papers Occasionally disappointment with techniques and effects results from choosing the wrong type of paper. Look at Chapter 2 for more information on papers (page 18).
- Details As a rule, when painting in watercolour it is best to use the largest brush with which you feel confident. Indeed, a great many effects are possible using a good quality, large pointed sable brush, but don't expect it to cope with really fine lines and details. Select an appropriate brush, such as a rigger, for the details in your painting but, as in all techniques, don't overplay such effects.
- Blotchy washes Sometimes, what should to be an even area of colour wash dries patchily. Usually the reason for this is that you have used too small a brush to apply the wash: you have brushed the wash in too much rather than single broad strokes across the area, or you have worked back over or into the wash while it was still wet.

Projects

- 1 On some offcuts or small sheets of paper try out all the texture techniques described at the beginning of this chapter. Label them all on the back with a brief description, such as 'wash over wax crayon', to remind you how each effect was achieved and keep them for future reference. Now complete a small painting (A3 size) which incorporates several of these texture techniques. Choose a subject which includes various textured surfaces. This could be a still life which you have arranged yourself, an interesting corner of a room, a single item like a pot plant, or a landscape view with foliage, grasses, ploughed fields and other textures.
- 2 Look at plate 6 and try a similar landscape painting of your own. As I have done, combine whatever techniques are necessary to achieve the effects you want.
- 3 Check through the Correcting Mistakes section again. See if any of the problem areas mentioned here relate to your own work. If so, read the advice and practise the technique a few more times until you feel more confident about it.

6 KEEPING A SKETCHBOOK

Drawing ability is fundamental to all forms of creative expression in art and it is not necessarily inseparable from painting. While drawing and painting may appear to require different skills, in fact there is a lot of common ground between the two. An accurate outline drawing, for example, will often form the starting point for a successful painting. If you can draw with reasonable competence you will be able to collect informative reference sketches and also begin your paintings with a sound preliminary underdrawing. In turn, this will encourage confidence to develop your watercolour painting techniques.

Sketching serves four main purposes: to improve your drawing skills; to train your sense of observation and perception; to think through and plan ideas ready for painting; and to provide useful reference material. Regard your sketchbook as one of your most essential items of equipment and use it frequently and purposefully. As you will see, you will be able to make small, on-the-spot paintings in your sketchbook as well as drawings and sketches using a variety of other media and techniques. If possible, try to draw in your sketchbook every day, even if this is for only 10 minutes or so.

Why sketch?

Sketching will encourage you to look, enquire, understand and realise the potential of different subjects and ideas, so it is a tremendously valuable aspect of the process of learning to paint. Sometimes sketching is a means of 'thinking' with your pencil. To be able to sketch out a notion quickly, clearly and concisely is always an asset. At other times, sketching proves a splendid preface to painting and is a means of getting to know a subject, its special qualities and characteristics as well as its difficulties and problem areas.

Your reasons for sketching will vary, with the resulting sketches taking a particular form to meet the needs of specific circumstances and requirements. Sketching can be the intentional gathering of reference material, suggestions and ideas; the initial plan, design or composition; the study of a detail; a series of viewpoints; or just for fun. Put another way, the aim of an individual sketch might be for information, observation, analysis, preparation or enjoyment. It follows that an appropriate method or technique has to be chosen in order to fulfil the purpose of the sketch. Consequently, sketches can range from just a few quick lines to plan something out, to a much more finished drawing for detailed reference.

Sketching is particularly relevant to landscape painting, the most popular subject for watercolourists. Most landscape painters rely exclusively on sketches as the source of reference for their studio paintings. It's good to paint on the spot, of course, but when this isn't possible, especially in the winter months, informative drawings are essential. Sketches can be made out of doors at any time of the year and the great advantage of using pencils, pens, pastels and so on instead of paints is that they are surprisingly versatile yet extremely lightweight, compact and easy to carry around. You will find that a selection of pencils and other basic sketching equipment will slip easily into your coat pocket. This means that you can travel light and consequently are able to wander well off the beaten track in search of ideas.

When using sketches, as reference or as the starting point for a painting, avoid the temptation just to copy them. Your painting should say something new and convey this in painterly terms rather than graphic ones. A painting which simply restates a sketch will obviously miss out on these qualities and, in turn, lack vigour and impact. A sketch might show the general arrangement or substance of an idea, or aim to capture a certain aspect of the subject – be this tonal values, different surface qualities and textures, shapes and relationships, or accurate detail.

Whatever the content or purpose of the sketch, use it as inspiration and information rather than something to be copied.

Choosing a sketchbook

Sketchbooks are sold under a variety of names, such as sketch blocks, drawing pads, layout pads and drawing books. You will find that they also vary in the type of paper used to make them. When buying a sketchbook the two main considerations are size and the type and quality of paper. Remember that the paper must suit the sort of media and techniques you intend to use. A thin cartridge pad, for example, while good for pencil sketches, will prove inadequate for watercolour washes.

To begin with, buy an A4 spiral-bound sketchbook which has about 20 sheets of 90 lb/185 gsm watercolour paper. The advantage of this particular type of paper is that it is not too rough in surface texture and therefore it can be used both for dry-sketching methods with pencils, pastels and charcoal, as well as wet techniques using pen and wash, or watercolour. A recommended type of paper to look for is Bockingford, although most other well-known watercolour papers are also available in sketchbook form. A spiral-bound book will open up easily and allow any used sheets to be folded underneath while you are sketching. Try to find one which has a stiff backing cover, as this will provide a firm support to press down on.

An A4 sketchbook is not too inhibiting in size but it is large enough to allow you to develop ideas adequately. However, you won't always want to carry any obvious sketching materials around with you - you may simply be out for a walk, for example, or shopping. For these occasions take just a small pocket-sized sketchbook and a pencil or pen. An A6 book with stiff, board covers and leaves of 70 lb/150 gsm cartridge or bond paper is ideal. Use it to jot down those unexpected ideas, notes and flashes of inspiration. As you gain experience and develop your sketching techniques you may find that you want to work on a larger scale or use another type of sketchbook. Indeed, quite possibly you will need several sketchbooks, with each one catering for a different medium, subject matter and so on. General purpose sketchbooks, such as the Winsor & Newton Artemedia pads or Daler-Rowney's Ivorex Drawing Books are extremely useful, but in a sense these are a compromise, for while they offer the possibility of using all sorts of media and combinations of media within the same book, the paper itself isn't specifically suitable for any of them and consequently the full potential of the media cannot be explored. So, in time and as you discover which media you like best,

you might wish to supplement a good-quality watercolour pad with others containing paper specifically for pastel, inks, charcoal, pencils, or whatever.

Larger art shops stock a range of sketchbooks, from cartridge drawing books to layout and calligraphy pads for pen and ink work and different watercolour sketchbooks, and they should be able to help and advise you. An alternative to the conventional sketchbook is to make one of your own. One way of doing this is to use an A4 ring binder and loose sheets of different types of paper, thus providing for a whole range of media and techniques.

How to use your sketchbook

Try to use your sketchbook in a versatile and uninhibited way. Don't be afraid to experiment and investigate new ideas, techniques and media. It doesn't matter if you make mistakes or produce what you feel are bad sketches. Indeed, there may be lots of ideas which do not work in the sense that they are of no great significance in themselves and will not be of value in developing future paintings. However, every sketch will add to your experience and possibly teach you something about observation or drawing technique. Generally speaking, a sketchbook isn't the place for highly finished drawings: one of its main purposes is to provide somewhere to thrash out ideas and solve problems. Remember that it is your personal visual notebook. You do not have to show it to anyone else, so you can be as bold, expressive and individual as you wish.

Time is frequently a limiting factor, creating the need to set down an idea simply and concisely. The aims of a sketch will usually be different from those of a drawing, but this is not to say that your sketchbook cannot include some detailed studies as well as those using your sketching 'shorthand'. Whatever form they take, you should never regard sketches just as something which shouldn't take much time or trouble. Sketches should jog the memory, excite and inform. If they fail to do this then they will prove more of a frustration than an asset.

If you can, resist the temptation to tear out really bad sketches from your sketchbook. Think of your sketchbook as a working record of your thoughts, ideas, successes and failures. Even a bad sketch might, at a later date, prompt an idea or prove useful in some way. Sometimes it is

possible to return to a half-finished sketch and develop it, perhaps with a different emphasis or using another medium. Looking through a sketchbook it is helpful to see how improvements have been made, which ideas work best, and which techniques need more practice.

Sometimes you will find that you have literally only two or three minutes to jot down an idea in your sketchbook. In these situations you probably won't have time to capture everything in the form of drawing, and you certainly won't be able to include all the colour and detail reference you would like. So, make a line drawing and then add written notes to remind you of things – the source and direction of light, for example, or a particular type of texture or colour.

Photographs can also be a help and you can stick these in your sketch-book for use in conjunction with relevant drawings. Here, cameras, like a Polaroid Instant Camera, can be useful because you won't have to wait until the whole film has been taken and processed before you have the necessary images to work from. However, be wary of working from photographs. In fact the camera *does* lie, especially with regard to perspective, both vertical and horizontal, which it frequently distorts or exaggerates. Colour, too, is not necessarily accurate, but photographs can provide you with extra information to jog your memory as well as a range of viewpoints, different composition suggestions, and so on. Look on photographs as an aid to your sketches rather than something to be slavishly copied.

Sketching media and techniques

Sketching embraces many skills and techniques and can be used in a wide variety of situations and applications. A sketch can be made in brush and paint, just as it can in felt-tip pen or 6B pencil: there are all sorts of media and techniques to choose from. It is a good idea to try out as many of these as possible until you find those methods and approaches which best suit the sort of sketches and information gathering you require. In any case, it is likely that you will need to be confident in a number of techniques, so that you can cover various types of sketches – from making a study of a particular detail to providing some colour reference.

Here are some suggestions for sketching media and techniques:

Pencils

As well as being the most obvious of all the different sketching media, perhaps surprisingly, pencils are also the most versatile. They are ideal for quick line sketches, tonal studies and detail drawings. Depending on the way that it is held and the degree of pressure applied, a single pencil is capable of great sensitivity and expression in the wide variety of marks, lines and tones it can produce, as in illustration 29. You won't need to buy a great range of pencils, an HB, B, 2B and 6B will give you plenty of scope. Look out for good-quality graphite sketching pencils and choose well-known brand names such as Rexel Derwent, Staedtler, Conté, Daler, Liquitex, and so on.

29 Pencil sketch

Pencil lines can be erased with a wedge-shaped plastic or rubber eraser, or a softer, kneadable putty eraser. However, keep any rubbing-out to a minimum, for sketches which are fussed over in this way tend not to work. Your eraser can also be used for softening tones, lifting out

highlights and blending edges. Colour and water-soluble pencils are also excellent for sketching. With colour pencils, like any other sketching medium, stick to a few basic colours. A vast array of colours serves only to complicate the sketching process and will probably lessen the effectiveness of the result. Another thing to watch out for when using pencils is their ability to lead you into drawing with a lot of detail and finish. As in all sketching, remember to concentrate on the important characteristics and elements of the idea or subject matter.

Water-soluble pencils are also available and the great advantage of these is that you can combine dry colour and fine, defined lines with broader areas of colour wash. When you have applied the dry colour you can wet it with a soft brush dipped in some clean water and consequently transform it into an area of 'watercolour' wash or manipulate it into some other texture or paint finish. So, a few water-soluble coloured pencils are ideal for line-and-wash sketches. Similarly, you can buy water-soluble graphite sketching pencils which will give a range of grey, tonal wash effects.

Charcoal

This is a wonderful medium for quick line-and-tone sketches. All you need are one or two sticks of willow charcoal and a couple of charcoal sketching pencils. The willow charcoal is available in different thicknesses and the pencils in a range of degrees from hard to soft.

Use the stick charcoal sparingly, gradually building up the strength of tones you require. You will find that you can work the charcoal deposit into the paper surface using your fingers or a piece of cotton wool, paper or rag. In a similar way you can fade and blend tones. Broad sweeps of shading are applied using the charcoal stick on its side, while finer lines can be drawn using the worn edge at the end of a stick.

Pressure is the key factor, with light pressure giving fine, sensitive lines and heavy pressure giving broad, dark lines. Don't press too hard or the charcoal stick merely crumbles or snaps.

Use a kneadable putty eraser to lift out highlights and soften tones. Work on cartridge paper, or watercolour papers or pastel paper if you want a more open, broken tone effect. You can combine stick charcoal with charcoal pencils where you need some defined lines and details, as shown in illustration 30. When completed, charcoal sketches should be sprayed with fixative to prevent them smudging.

30 Charcoal sketch

Pens

Pen and ink has been a popular sketching technique for many centuries. Pen lines are extremely expressive and individual, just as the overall impact of a pen drawing on white paper is usually lively and powerful. Perhaps the best thing about pens is that they encourage us to make a confident drawing statement, for unlike pencils and other sketching media, it isn't easy to erase or lift out marks made with a pen. Consequently, pens are excellent for bold line drawing and quick 'notetype' sketches and ideas.

Among the many different types of drawing pens found in art shops look for disposable fineline pens and refillable art pens. The advantage with

31 Landscape sketch made with a fineline art pen

these is that you will not need to dip the pen in a separate bottle of ink, but can rely on a built-in free-flowing supply. Disposable pens generally have a fixed nib, while other art pens have interchangeable nibs. Various nib widths are available, usually from extra-fine (about .25 mm) to wide (about 1 mm). Black is best for most sketching ideas, but you can supplement this will other colours if you wish, although these inks tend to be rather vivid in colour. The ink used may be waterproof or water-soluble when it dries. Choose waterproof ink if you intend combining the ink drawing with subsequent colour washes. The landscape sketch in illustration 31 was made with a fineline, refillable art/technical pen, while the figure study in illustration 32 was made with a disposable pen.

32 Figure study sketched with a disposable pen

Most pens work satisfactorily on cartridge paper but better on thinner, layout paper. You can combine fineline pens with wider felt-tip pens and markers in order to achieve contrasting strengths of line and depths of tone in your sketches.

Pastels

Like charcoal, soft pastels are splendid for quick, vigorous sketches, this time in colour. Pastels are made in square and round sticks, usually about 2¹/₂ in or 60 mm long, and the dry, dusty colour is opaque. The square pastels are firmer, making them suitable for detailed linear work as well as general areas of colour.

Work in a similar way to charcoal, applying the colour gradually and fading or blending it where necessary by lightly rubbing it with your fingers. Keep to a limited palette (range of colour) and preferably work on a slightly coarse or textured paper. Overworked areas can be reduced by dabbing them with a kneadable putty eraser and highlights lifted out in the same way. You can use stick pastels for a preliminary broad treatment and combine these with pastel pencils to add sharper lines and details. Water-soluble pastels are also available and, like their pencil namesakes, these can be used where you want a combination of dry techniques and wash effects.

Colour reference is often extremely important in sketching, especially when tackling the transient nature of a cloudy sky or a similar subject. Soft pastels are a quick, effective colour-sketching medium and they are particularly good for capturing the essence of a scene, its mood and atmosphere. Completed sketches in soft pastel should be sprayed with fixative to prevent them smudging.

Watercolour

In the main, all the sketching media mentioned so far will allow you to work with dry pigment using fairly controlled methods. Additionally they are self-contained media in the sense that they do not rely on being diluted with water or involve the use of any auxiliary equipment. Of course, in many sketching situations there are advantages in being able to work in this manner and not having to carry much around with you in the way of materials and equipment.

However, on other occasions it makes sense to work directly with watercolour. Sketching in watercolour will provide you with more opportunities to practise techniques and experiment with new ones. It also allows you to get an initial feeling for the subject or idea in the same medium which you will be using later on to paint the final picture. Like other sketches, the intention of watercolour studies might be to provide reference information or the genesis from which a fully resolved painting can be developed. Equally, a watercolour sketch could be regarded as complete in itself, as something which can be further worked on back in the studio or as the basic composition and idea for interpretation in a more resolved way and on a larger scale. The sketch shown in illustration 1, for example, is a preliminary study for the final painting shown in plate 6.

There are various types of watercolour sketchbooks to choose from. The heavier quality 140 lb/300 gsm pads will accept washes of colour better and are good for subjects which invite a loose, general treatment, while for flower studies and other ideas which need more control and detail choose a smoother, lighter-weight paper. Especially when painting outside, restrict your painting equipment to the minimum. Actually, you need only three tubes of paint (primary colours), a large and a small brush, a water container, a small mixing palette, a piece of tissue paper or rag and your sketchbook. There is further information and advice on painting outdoors in Chapter 9.

Line and wash

33 Ink-and-wash sketch

This is one of the most useful of sketching techniques. It involves making a preliminary line drawing and then adding an indication of colour in the form of loose, general washes, see illustration 33. Alternatively, you can start with a brush-and-wash drawing and then add a few outlines to define certain parts, or use lines to suggest some detail here and there. The lines can be drawn in pencil or pen, while the wash can be weak watercolour or created from water-soluble pencils. If you work in pen ensure that the ink is waterproof, unless you intend the lines to bleed into the wash areas. Other sketches can use a combination of wash and brush lines, as in illustration 34.

34 Wash-and-brush drawing

Mixed media

Naturally, sketches need not be confined to a single medium or technique. As you become familiar with different methods and media you will find that you want to combine appropriate techniques in order to achieve really effective results. In fact, most media will work quite happily together, although generally it is best to combine just two or three. A recommended approach is to use one medium (perhaps pencil, pen or

charcoal) to lay in the main shapes and basic tones, changing to another (perhaps pastel, coloured pencil or watercolour) to add relevant colour.

Charcoal and watercolour is a mixed-media technique which works well, (see plate 5). The charcoal gives the necessary underlying structure, form and tone, while the watercolour provides colour and atmosphere. For tonal studies try a combination of pencil, pen and charcoal. As with all aspects of painting, the best way to learn about mixed-media techniques is to try them out for yourself, to experiment. After all, testing the potential of different media should be one of the main uses of your sketchbook.

Observation and ideas

While a drawing or painting could tell us practically all there is to know about its subject matter, a sketch will have different objectives. Usually, a sketch has a more obvious focus: it is selective and specific. Therefore, before you begin to sketch you have to look carefully at the subject matter, decide what you want to say about it, and then concentrate on this aspect in creating the sketch. So, in broad terms, the sketching process is observation, selection and interpretation. A key word in sketching, and indeed in art generally, is observation – not just looking, but seeing and noticing. To draw or paint something convincingly you must first understand what's there. This is done by viewing the subject matter in an enquiring, inquisitive way and not making any preconceived judgements about it. A lot of information has to be assimilated in a relatively short space of time, from the principal shapes which make up the subject matter to the relative position of things and their surface colour, texture and detail. In sketching, because the pace of action is quicker, it is vital that your observation is sharp and decisive.

Poor sketches can be just as much the result of inaccurate observation as of limited technical skills. Observation improves with practice and experience, of course, but to begin with it is necessary to make a conscious effort to notice and check certain points. Sketching, more than any type of drawing, has to convey the essentials of an idea or subject. So, look for a foundation structure on which to build your sketch – main shapes, helpful lines and comparative proportions and positions. Keep the whole sketch in mind as you look at and compare one part with another. Working from this basis you can then develop the sketch in whatever direction you wish. Remember, don't fuss over it too much, keep it lively and informative, and enjoy it!

Especially when working outdoors, use a strong elastic band or a couple of bulldog clips to hold down the pages of your sketchbook while you are drawing and painting. This will stop them lifting in the wind and becoming creased or damaged. Also, take along a plastic or polythene bag to protect your sketchbook if it rains.

Sketching materials like pastels, charcoal and pencils are easily crushed or damaged, so don't carry them around all together in a soft, zip-fastened pencil case or similar container. Instead, use a strong cardboard or plastic box and preferably one which has one or two separate compartments. You can protect pastels, charcoal and other delicate materials by placing them on some cotton wool.

Projects

- 1 Get to know a new sketching medium by taking a page in your sketch-book to test the marks, lines, tones, colours, textures and effects it will make. When you have explored the possibilities, try a little sketch which incorporates some of the effects you have discovered.
- 2 Look for an interesting, ready-made still-life group somewhere around the house. This could be a collection of objects on a shelf, kitchen utensils, plant pots on the patio, items found in a garden shed or greenhouse, and so on. Look for a group of perhaps three or four objects which shows some contrasting shapes, colours and surfaces. There's no need to make a formal still life out of them by moving things around try to sketch them just as they are. Start by making a pencil line sketch of the group and then try a tonal sketch using soft pencil (4B) or charcoal. Here, concentrate on the different light and dark shapes.
 - Now try a colour sketch, perhaps from a different viewpoint, using whatever medium or combination of media you feel is appropriate.
- 3 Choose an outdoor theme which appeals to you. For example, this could be an interesting old building, a landscape view or a high-street scene. Over a period of time make a series of sketches that will give you all the information you need to compose a well-finished, studio-based painting later on.

PART 2 IDEAS AND PROJECTS

PLANNING YOUR PAINTING

Some types of subject matter will appeal to you much more than others and these will naturally influence your working methods. If you enjoy landscape, for example, you may prefer to paint on the spot directly from the subject rather than indoors. Alternatively, if you like portraits or stillifes, these must be painted inside, although even here you could work alla prima or spontaneously without a lot of initial planning and preparation.

Whatever your usual approach it is likely that occasionally you will want to produce a carefully thought out and resolved painting developed from sketches or other reference material – what might be termed a 'studio picture'. This chapter examines the main points and the different stages to consider when contemplating a painting of this kind. Good planning and organisation will help you tackle an idea with confidence and success, although it shouldn't be at the expense of vigour and interest in the final work. Have your aims and intentions clear, but always leave something to discover in the painting process.

Finding a subject

Interpretation stems from observation and understanding and therefore you will probably produce your best paintings from subject matter which interests you and which you know something about. Choose ideas that you want to paint rather than those you feel you should paint and start with subjects familiar to you. However, don't be tempted to 'play safe' all the time. It is important that every picture offers a new challenge, otherwise it becomes merely a tired repetition of a well-known and possibly exhausted theme. If a painting demands a little extra from you it is not only more likely to succeed, it will also add to your experience and general development. You may never tire of a few set

themes, of course, but you must be able to tackle them each time with a fresh approach and so keep the paintings vital and effective. Look for unusual viewpoints, different techniques and other ways of doing things.

Ideas and inspiration can be found in the most unlikely places; subjects don't have to be complex and colourful to succeed. Commonplace objects will spring to life when seen in a dramatic light or an original composition, for example. Similarly it may be the use of exaggerated perspective, the relationship of shapes, or the dependence on an unusual technique which is the real subject matter of the painting. The particular character or mood of a given subject might suggest that it is just the thing to interpret with watercolour.

Subject matter can range from detailed realism to completely abstract. It can embrace various approaches to natural forms, still lifes, land-scapes, figures and portraits, as well as include ideas developed from fantasy and imagination.

In addition to your own thoughts, ideas and sketches, you can be inspired by the work of other artists, or find general themes to develop from sketches, photographs and similar visual material. Whether the drama of a sweeping landscape, the subtleties of light in a group of objects, delicate flesh tints in a life study, or the blushes of colour in a summer garden, subject matter is everywhere. The scope is boundless!

Roughs and research

A rough is usually a simple, small sketch – perhaps just a few lines made with a pencil or pen. You can use roughs to:

- Get you started for thinking through an idea in a visual way, brainstorming and experimenting with basic ideas;
- Help you understand as preliminary sketches to familiarise you with the subject matter before tackling it in detail:
- Select and compose as quick sketches of different viewpoints or parts of a complex subject to help you identify the most interesting area for closer scrutiny in the painting, and as a means of experimenting with design and composition alternatives;

■ Try out techniques – for testing the suitability of a particular technique or to check whether the paper will respond in the way you require.

Even if you are painting directly from the subject matter, rather than from drawings and photographs, roughs are useful for establishing the general layout of the composition, getting a feel for tonal relationships, and so on. Make any rough sketches of this sort in your sketchbook or as an easy-to-compare sequence on a large sheet of paper. As well as pencil and pens, try using other quick sketching media, such as pastel, charcoal and even watercolour itself.

For studio paintings you will require some more deliberate reference studies and investigations to work from. In fact, you may need a number of these in order to provide an adequate amount of information from which to compose and paint the picture. Chapter 6, *Keeping a Sketchbook*, has advice on suitable media and techniques.

Your research can be in the form of:

- Location studies Use your sketchbook and make some drawings and paintings on the spot to give an overall impression of the subject as well as specific information about details, textures and features.
- **Preliminary studies** Investigate different viewpoints, the sort of design and composition you want and any difficult parts of the subject before beginning the actual painting.
- Using photographs Remember that photographs often distort colour, scale and perspective. Use them as reference rather than for copying. They can be helpful as an *aide-mémoire*, for providing information on specific details and for recording transient subjects, such as a speeding train.
- Inspiration from other artists Visit galleries and exhibitions to view paintings by well-known artists at first hand. Books and videos will also provide information. Studying the work of other artists is another way of increasing your knowledge and understanding of drawing, and helping with your own ideas and technical problems.

Aims and impact

Whatever your subject matter you will find that you work more positively and successfully if you have clear aims and are trying to create something specific. Often, the subject matter itself will suggest a special emphasis or approach, perhaps through its strong colour, contrasting shadows, interesting textures, and so on. If you know what you are trying to achieve in the painting you are more likely to achieve it!

Your aim could be to make a carefully observed and detailed study of something, or it may be more personal and interpretative, such as to capture the mood and atmosphere of a bracing estuary scene. It might be to examine the relationship of shapes and colours in a particular subject, to explore an individual technique or to concentrate on the use of a limited palette. The aim will set you a problem and focus your attention in a certain direction.

Choosing the right paper

You may well get used to a favourite type of paper, but be prepared to experiment. The type of paper can have a tremendous influence on different paintings and effects, so think ahead and consider the range of techniques you are likely to be using – it is vital to choose the most suitable paper. Remember that a hot-pressed (HP) paper will be good for controlled and detailed work, a Not paper will suit washes and general techniques, and a rough paper is the ideal choice for dry-brush and similar texture effects, lifting out and generous washes. Chapter 2 has more information on paper.

If you are not sure whether a certain type of paper is the best choice, experiment first by trying out particular effects on a scrap piece of paper. Save offcuts and the backs of rejected paintings for this purpose. Most watercolour papers need stretching or taping down in some way before you start painting, see Chapter 2. After stretching, depending on the subject matter and intended approach, you may need to treat the paper with an initial foundation stain or wash of colour. This can be quickly applied with a sponge or large, flat, soft-hair brush. Paintings which involve resist techniques or masking fluid may require applications of wax, fluid, etc. at this stage as a basic preparation.

Working through stages

Now look at illustrations 35 to 38 in conjunction with the advice below and see how you can work through a watercolour painting stage by stage.

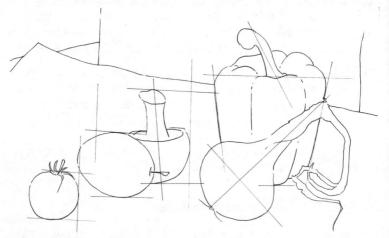

35 Still life stage one: making the initial drawing

- Composition From your collection of reference material (sketches, photographs, and so on), you will need to deliberate over the best way to shape the idea into an exciting composition. You may decide to combine parts of various sketches, or you may have done a careful study which shows exactly the image you want to translate into a final painting.
- Planning What are your aims for the painting? As well as the selection and preparation of the paper, think about the size and shape of the work, the colour key and mood, and any particular effects and interpretation you want to convey.
- Outline sketch Use a sharp, soft pencil to lightly sketch in the main shapes on the prepared watercolour paper. Keep such drawing to the bare minimum. In landscape paintings I usually leave out this stage of the work altogether, preferring to start directly with a series of basic washes. However, an initial drawing of this kind is recommended because it

will establish a good underlying structure for the painting and give you confidence when it comes to applying colour. Remember that any drawing must be faint, unobtrusive and capable of being lost as the different washes are applied. Try not to erase any lines unless absolutely necessary, for this can scuff up the surface of the paper and subsequently create uneven patches of colour. If you do have to rub anything out then use a putty eraser, dabbing the lines rather than rubbing them.

■ Enlarging a sketch If you are working from a small sketch, ensure that the painting paper is in proportion to the original idea. You may wish to enlarge the sketch by squaring-up or another method, see Chapter 10.

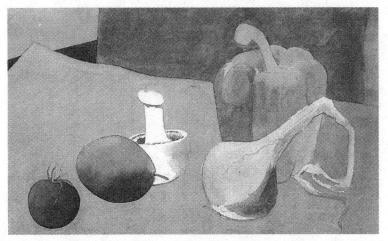

36 Still life stage two: laying in foundation washes

- Preparing to paint Have all your painting equipment ready and decide on a palette (range of colours) suitable for the subject matter and effects you have in mind. If required, mask out highlights and other white areas with masking fluid.
- Background Start with the background, which will set a colour/tonal key for the whole painting. If it is a sky, then complete this in one go, as you will probably need to work

with a wet-in-wet technique to create the right effects. Have the necessary washes mixed and ready, and use your largest brushes to begin with. You will want to create a feeling of space and depth, so remember to keep the background colours weak and low key. More information on painting skies is given in Chapter 9. In other subjects the background may involve cast shadows. Add these later, when you are considering shadows in other parts of the picture.

■ Initial washes Use general washes to block in the remaining shapes, remembering to reserve any white parts. The colour and strength of these washes can contribute to a general indication of space and form. These will represent the lightest tones.

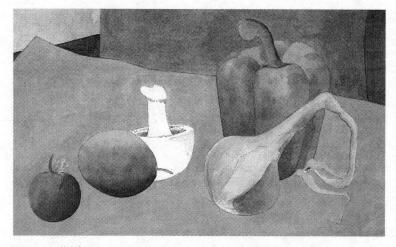

- 37 Still life stage three: beginning to develop tonal contrasts
 - Developing with further washes Now concentrate on developing the tonal contrast. Look at the various lights and darks. You may need to exaggerate these in order to create interest and impact. Use a succession of washes to build up the darks, allowing each one to dry before working over it. Ignore details.

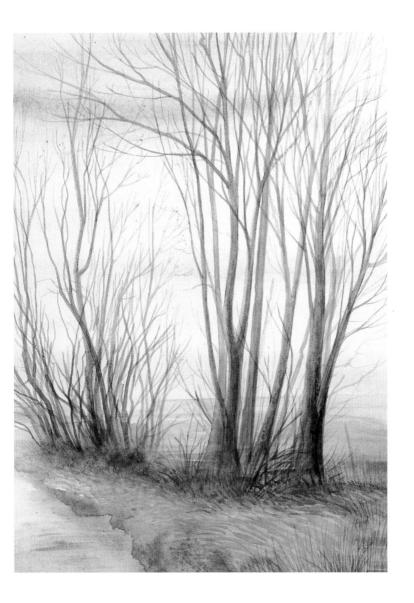

Plate 8 Winter Mist, Dartmoor, watercolour on $140 \, lb/300 \, gsm$ Cotman paper using a limited palette and mostly wet-in-wet technique, size $28 \times 21 \, cm$

Plate 9 Leek study, first stage

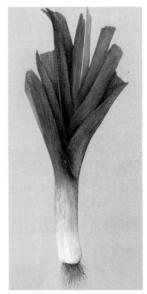

Plate 10 Leek study, final stage

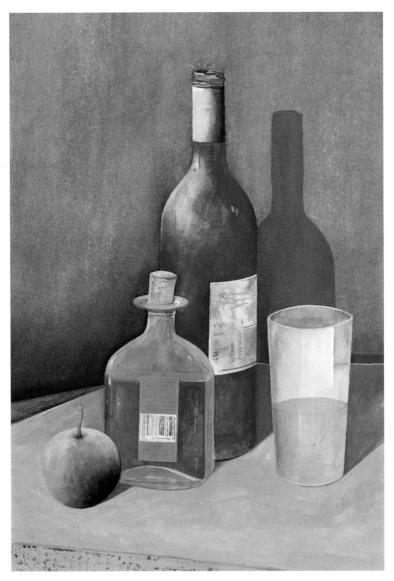

Plate 11 Still life combining a variety of techniques, including the use of scratching-out (background), gouache (bottle), wet-in-wet (glass) and wax resist (foreground)

Plate 12 Portrait study using thin washes of colour

■ Special effects As you establish the tonal variations you may have to consider particular techniques to suggest different surface effects and textures: perhaps wax resist, dry-brush, and so on. Use appropriate brushes. Refer to Chapters 4 and 5 if you need to revise any techniques. Paint in cast shadows.

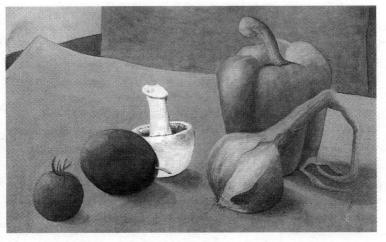

38 Still life stage four: final painting

■ Details Use a small pointed brush or rigger to add details where required. Similarly, add dashes of high-key or special colours. Tidy up edges and check the overall effect of the painting. Don't fuss too much, but little adjustments can be made to shapes, colours, and so on if they are really necessary. Start from the top (background) and work towards the bottom (foreground). Concentrate most of the detail in the foreground area. Remove masking fluid, if used, and possibly tone down some of the white parts.

While this is the usual way of working, you will appreciate that each painting is slightly different and the painting process will depend on the subject matter, techniques and particular emphasis and approach you wish to adopt.

The four stages of the still-life painting shown in illustrations 35 to 38 demonstrate the general procedure.

The first aspects to consider are the viewpoint and the composition. Obviously, in a still life you can choose your own objects and arrange them as you wish, but you need to think carefully about what you choose and how the different shapes relate to each other to create an interesting group. Place your still life on a tray or board, then, if needs be, you can move it to a different position without having to dismantle the whole group.

Notice that I have positioned the largest item on the right, thereby making an overall triangular composition, yet not too balanced. I've also considered the sort of shapes created between the various objects and have tried to achieve some variety with angles, heights and so on. The simple background does just enough to break up the surrounding space and unify the group.

Working on 90 lb/180 gsm stretched cartridge paper I began by plotting an outline drawing, as shown in illustration 35. In such a drawing, use whatever guide lines you need to help you work out the relative size, angle and position of each shape. Keep these lines faint. The lines in my drawing have been deliberately emphasised so that you can see them clearly. Don't put in more lines than are absolutely necessary. When you have established workable outline shapes carefully rub out any other guide lines with a putty eraser.

The next stage (illustration 36) is to block in the main shapes with general washes of colour. Notice any white or highlight areas which you may need to leave as unpainted paper and apply a weak wash to the remaining areas, equivalent to the lightest tone.

Consider the palette (range of colours) you will need. My palette consisted of alizarin crimson, cadmium red, burnt umber, raw sienna, ultramarine, cadmium orange, cobalt violet and Payne's grey. Notice that to create the correct colours for the particular fruits involved I have had to supplement colours from the recommended basic palette with two additional ones: cadmium orange and cobalt violet.

Start with the main background areas and work forwards, finishing with the foreground shapes. I've used a round no. 10 sable brush for the general washes because this allows broad strokes as well as carefully controlled painting where necessary between and around the shapes. Avoid painting wet against wet, otherwise the washes will fuse and run. These washes create the foundation colours over which to work, so don't worry if they look rather patchy to begin with.

Now it is a question of establishing the light and dark (tonal) values within the painting, before adding more detail and definition. Avoid the temptation to completely finish one part and then move on to the next. Instead, try to keep the whole painting developing at the same pace.

From the initial flat washes start to consider what is necessary to model the three-dimensional forms and suggest space. Notice where the light is coming from and how this creates variations of tone across the surface of the individual shapes.

Use a succession of washes to build up the appropriate strength of colour, letting each wash dry, or nearly dry, before the next is applied. You may need to suggest a subtle blended effect by applying new colour on to the slightly damp surface of the previous wash. Or, as I have done with the plum in my still life, you may have to work wet-in-wet to convey a transition of colour with no obvious edges.

Illustration 37 shows the tonal qualities beginning to be developed, while illustration 38 shows the completed painting after final details and shadows have been added. The base shadows were put in using a wash of cobalt violet and Payne's grey, with the edges wetted in to the surrounded area with a brush dipped in clean water.

Projects

- 1 Refer to illustrations 35 to 38 and the information about each stage of working described above. Set up a similar simple still-life composition of your own which is based on a small selection of fruits and vegetables. Choose some contrasting shapes, sizes and colours and pay particular attention to the overall composition. Make a painting of this group, working through the stages illustrated.
- 2 Look in your sketchbook to find a suitable drawing which you could use as a reference study for a painting. Perhaps one of the sketches you did at the end of Chapter 6 will do? Referring to the stages outlined above, paint a watercolour from the sketch. Work on an A3 sheet of paper or larger.
- 3 Taking buildings as a general theme, collect some ideas and information in your sketchbook. Look for a building or part of a building with some interesting architectural features or character and choose an unusual viewpoint. Make at least one colour study as well as other sketches, notes and details which will make useful reference material. Design and paint a watercolour from your sketches. Plan your work carefully.

8 PAINTING FROM OBSERVATION

Certainly to begin with your intention will be to make a painting of the subject rather than work from it. In other words you will want to interpret what you see as realistically and accurately as possible. Later you may wish to adopt a more selective and subjective approach and give a strong, personal emphasis in the way the subject matter or idea is painted. As with the different techniques explained in Part 1, once you have acquired the basic skills – in this case of looking, understanding and working from observation – you can begin to develop your own style and individuality.

When we set out to paint a straightforward likeness of an object or view in front of us this is known as working from direct observation. Confronted with the problem of translating the subject matter before us into a convincing painting, we must first look and understand, So, an important aspect of learning to paint is, in fact, learning to look and notice things. As well as obvious qualities, such as colour, we need to note proportions, structure, form, tone, details, particular characteristics and surface textures and so on, and how these all relate. Artists must be nosy and enquiring!

Observation usually means a long, hard, studious, analytical look, for a casual glance will merely give you limited, perhaps even distorted information to work from. Get into the habit of viewing subjects in this sort of fresh, investigative way, even if they are subjects you have painted before and think you know well. Preliminary sketches and drawings always help in this respect. Chapter 6, *Keeping a Sketchbook* will give you more information on sketching and drawing techniques, while *Teach Yourself Drawing* (ISBN 0 340 58306 1) offers an easy-to-follow, well-structured and comprehensive drawing course and makes an excellent companion volume to this book.

Before you start painting from observation think about these points:

- the most suitable type of paper and painting techniques
- the main shapes of the composition and how these interrelate
- the size and proportion of each of these shapes
- structure how the shapes are formed
- light and dark contrasts
- colour selection of a particular palette (range of colours)
- surface textures and details where relevant.

Scale, composition and tonal values are especially important in observation work, so let's look at each of these topics in more detail.

Scale, proportion and perspective

The relative size of one object to the next helps to convey a feeling of space and depth in a painting. Many landscape artists, for example, will include one or two small figures in order to set a comparative scale and thereby give a greater sense of distance (see illustration 19). The viewpoint you choose and the way that you compose the picture can also help. An obvious example is when painting a building: if you take a straight-on viewpoint the building looks flat and lacking in three-dimensional form, whereas if your viewpoint is from one end, the building assumes a much more interesting and dramatic angle. This not only automatically acts as a compositional device to lead your eye into the painting, but through its recession and consequently diminishing scale it also creates the illusion of depth.

In many ways painting is often involved with suggestion and illusion. The fact is that we paint on a flat sheet of paper and yet have to represent the idea of three-dimensional objects. In this context it helps to think of the edges of your sheet of paper as a kind of window frame through which you are looking. An important fundamental division within this is the horizon or eye-level (for landscapes and other outside subjects) or base line (for still lifes, interiors and figure studies). Once you have established this line you will have worked out your 'ground' area. Broadly speaking anything above this line is background, while the size of anything below the line will be influenced by its position in relation to the bottom edge of the paper. Distant shapes (on the horizon)

appear much smaller in contrast to the foreground shapes (near the bottom edge of the paper).

When drawing or painting a particular shape, remember to plot its position and size with reference to other parts of the composition. Always in a painting the 'weight' of individual parts must be considered in relation to the whole, for in the final analysis it is the overall effect that counts. As an aid to drawing something the right size it may help to use a few faint guide lines.

Perspective will apply to subjects such as roads and buildings, which have straight edges, parallel sides and are set at an angle to the viewer. Consequently, these subjects seem to taper or recede into the picture. The basic principle is that such receding parallel lines appear to converge and that if extended far enough they would eventually meet at a point on the horizon or eye-level known as the vanishing point. Frequently however, this point is outside the picture area. See illustration 39.

39 Perspective

Beginners are often over-awed by the assumed complexity of perspective and its application when drawing different subjects. Frankly, there is no need to worry unduly about the theory. There is such a lot to grasp when you first start painting that I would leave the intricacies of perspective for a later date. You won't go far wrong if you observe carefully the angles and positions of things and you bear in mind the principle of perspective, as outlined above.

Painting and composing

The best paintings combine interesting subject matter and technical skill with good composition. So, as well as being well painted your watercolours must be thoughtfully designed. This means selecting and arranging things in such a way that your eye is led round the painting, your attention is kept within the picture area and you focus on a particular point of interest. You will see that good composition can depend just as much on what you decide to leave out as on the way you organise and emphasise the remaining shapes.

Like most aspects of watercolour painting, there are no special rules or magic formulae which guarantee success. Again, it is more a question of being aware of the significance of this topic and avoiding one or two common mistakes than of following any prescribed procedures. Something which does help is to 'think through' a composition idea by making a series of quick, simple sketches. In this way you can get a feeling for the overall distribution of masses and shapes and how they create contrast, movement, focus and so on. Play around with the design in sketch form until it seems to work.

Here are further points to consider in planning your composition:

- Think about the size, shape and best way round to use your paper.
- Avoid equal emphasis and interest in all parts of the picture. Make some contrast between sizes, shapes and spaces, as well as movement and direction.
- Don't make your composition too balanced or symmetrical. In a landscape, for example, make the sky area larger than the land area, or vice versa. Similarly, in a still life, don't place all the objects in an equally spaced straight row.
- Use lines and shapes which lead to a main focal point. Normally this will be treated in more detail or be of a stronger tone or colour than the rest. Often the position of the focal point is related to a division known as the 'Golden Section'. This is an arrangement or proportion such that the small part to the larger is the same as the larger to the whole. Approximately, the ratio is two: three and this, of course, can be applied in any direction, horizontally or vertically. It means that roughly two-fifths across your painting you would place some significant feature of the composition.

Light and dark

The effect of light, from highlights to deep shadows, is another important element in any watercolour because, apart from its obvious use to model and describe individual objects, tone can play a vital part in the design or composition of a painting. For example, a long, diagonal shadow might be used to break up an empty foreground area and lead the eye across and consequently round the picture. So, shadows can create flow, direction and movement.

40 Winter Lane, watercolour on stretched cartridge paper, size 30 x 30cm

DODGEVILLE PUBLIC LIBRARY 139 S. IOWA ST. DODGEVILLE, WI 53533 Contrasts of light and dark will also add more interest to your paintings, of course, and are essential in establishing a certain mood and atmosphere. Think of how you might portray a stormy winter landscape, for example, where the emphasis might be on dark colours, heavy shadows and some aggression in the technique, as opposed to a bright, summer landscape, where high-key colour and lighter tones would be more suitable. In all paintings, it is a good idea to identify the source and direction of light and thus how this influences the strength and distribution of lights and darks. See also the section on Colour and Tone, in Chapter 3.

Consider the information below as you study illustrations 40 to 41. Then complete the projects listed at the end of this chapter.

Notice how scale, proportion and perspective are used in illustration 40 to create a feeling of great distance, yet within a relatively confined area of the painting. The lane tapers back and this sense of perspective is accentuated by the bordering grass verges and hedges, which recede in a similar way and carry the eye towards the horizon. The feeling of depth is further helped by the changing scale of the trees.

From the composition point of view, the arching trees, particularly the one in the foreground, are used to contain interest within the picture area. The horizontal shadows not only break across the strong shape of the lane but help to unite the foreground and lead your eye round the picture. This painting was started on location, where it was possible to make a close observation of the tree forms and other shapes, and completed in the studio, where the texture and detail could be fully resolved.

With its variety of buildings set at different angles, illustration 41 also involves a concern for perspective, this time coupled with a positive use of lights and darks. This subject was painted on a brilliantly sunny day (the light is coming from the right), which meant that the different surfaces of the buildings were either very light or very dark. Because the angles and shapes need to be as accurate as possible I decided to start with a carefully observed outline drawing, as in illustration 42. In fact, I've left quite a few of the pencil lines showing through in my painting, to give it the necessary definition and structure.

41 Houses at Lower Slaughter, location watercolour painted on 140 lb/300 gsm Bockingford paper, size 26 x 20cm

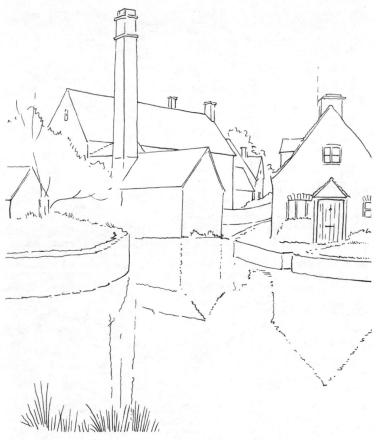

42 Houses at Lower Slaughter, inital sketch

Projects

- 1 Make a series or sequence of watercolour studies of fruit, vegetables or flowers. This could involve a number of different specimens, or the same specimen but viewed from various angles. Place the emphasis on accurate observation, as in plates 9 and 10.
- 2 Make a painting of an interior or exterior view of your house. Consider the influence of perspective and how you can suggest space and depth.

PAINTING OUTDOORS

For many, part of the attraction of painting is to get out and about, discovering new ideas and at the same time enjoying the fresh air. Landscape is the obvious subject matter, and certainly this includes an infinite variety of possibilities, from tranquil countryside corners to rugged mountains and impressive coastal scenery. However, there are plenty of other subjects too. Maybe your interests lie in visiting and painting gardens, or perhaps stately homes or other fine buildings, town-scapes, village scenes, animals and so on.

Of course, painting outside will require a different approach to the more leisurely and possibly complex methods you might use when at home. Time is always a limiting factor, as is the amount of equipment you can sensibly carry around. Consequently, you can't be too ambitious and you will probably have to paint on a smaller scale and in broader, less detailed terms than usual. This said, there is still plenty of scope for a lot of exciting and rewarding work, whether you aim for complete pictures, ideas that you can finish at a later date indoors, or reference sketches. A great advantage of working outdoors is that you are drawing and painting from direct observation and must be positive and decisive in attitude.

Being prepared

Travel light: you don't want to be burdened by a lot of heavy equipment. In any case, a limited choice will be less confusing and help you focus your working methods. Everything you need should fit into a single large bag or rucksack. Take a small, folding canvas-seated stool – something like a fisherman's stool – if you prefer to sit down to paint. Some rucksacks actually incorporate a seat of this type, see illustration 43.

Being prepared also means thinking about essentials like food and drink and sensible clothing, especially when you are going to be out all day. Take a stout, waterproof sleeve or folder to protect your sketchbook or watercolour paper from the rain.

43 Some outdoor painting equipment

Here is a list of things you might need for sketching and painting outdoors:

- sketchbook or various sheets of paper and a board to press on
- sketching media such as pencils, pens, charcoal, pastels and water-soluble pencils
- small box of watercolour paints
- screwtop bottle of water
- several brushes, pencil sharpener or knife, putty eraser and other items such as tissue or rag, fixative, masking fluid, bulldog clips and so on as required.

Selecting an idea

Some ideas immediately seem to catch your attention and will obviously make good paintings. On other occasions, the location might present a confusing array of possibilities and it is difficult to know what to choose as the subject for your picture. So, confronted by a busy street scene or a panoramic landscape, how can you isolate the best part?

A good method is to use a cardboard viewfinder. You can make one easily from a small sheet of card. Simply cut a rectangle measuring about $1 \times 1^{1}/2$ in or 25 mm \times 40 mm from the middle of a piece of 4 in \times 6 in or 100 mm \times 150 mm card. Sizes can vary according to the scale of work involved. Shut one eye and hold the viewfinder up to the other eye, moving the viewfinder around to compare different views. Try using it both landscape (horizontally) and portrait (vertically).

Remember that in general you are looking for an idea which has an interesting arrangement of the basic shapes and colours, and focuses your attention on a certain area or object. Look for contrasts of tone, scale and so on as well as the way that broad, simple areas relate to more detailed ones. Additionally, select something which sets you a bit of a challenge: in each new painting aim to stretch your skills and develop your work further. It may well be that a particular location, view or subject will offer various options and possibilities – perhaps by working from other viewpoints, concentrating on a certain quality or detail, or adopting a different approach and emphasis in interpretation.

Space and distance

Often when working outdoors you will have to condense an extensive scene or view on to a small sheet of paper. What is seen will have to be simplified, yet at the same time the original sense of depth and space must be maintained. Sometimes, faced with this problem of a tremendous reduction in scale, it is easy to lose sight of those features and elements within the subject that help to convey the feeling of distance.

Bear in mind the information given in Chapter 8 regarding scale, proportion and perspective and take note of any special feature in your landscape or other view which can help to provide a reference for scale. Contrasting a close-up foreground shape with much smaller and less

distinct background shapes is a useful way of creating an impression of depth. For example, you might use the dramatic change in scale between a large, foreground tree and the vague impression of hills and general landscape in the distance. Figures can also be useful, as mentioned later in this chapter.

Depth can be suggested by a careful use of colour. Because of the combined influences of distance and atmosphere, far off colours appear weaker and cooler – an effect known as aerial perspective. Distant hills, for example, may look blue. These low-key background colours will contrast with the warmer and stronger colours of the foreground, so emphasising any feeling of depth created by relative scale and other means. As well as including more positive colour, the nearer parts of your painting will also be the areas that need the most detailed treatment.

Feeling and atmosphere

There are two points to consider here: capturing the particular moment, the sense of place and special mood of the subject; and, perhaps intrinsically involved with that, painting to communicate a personal response. Outdoor subjects are obviously influenced by the weather, but this isn't the only factor that creates mood. The essential spirit of a subject might be in its exuberance (colour), its bustle and movement (composition) or its peace and tranquillity (tonal values) among other qualities.

Outdoor paintings and sketches are often made for reference rather than attempting to produce anything resolved and finished on the spot. When this is so, a priority must be to set down the principal characteristics of the subject matter and perhaps to support any drawings and paintings with written notes and photographs as an *aide-mémoire* about the location and its feeling and atmosphere. When you start to turn these sketches into well-finished paintings back at home, use all your reference material to help you recapture that particular feeling. Equally, concentrate on those painting techniques which will give the sort of effects and emphasis you need in order to convey a certain mood, and convey it with sensitivity and personality.

Now study illustrations 44 to 47 and the information on them given below. Then complete the projects listed at the end of this chapter.

Figures

The inclusion of one or two small, simple figures will give a sense of scale to a landscape scene, and add a focus and some extra interest. Additionally, such figures can be painted in a colour like red, that will complement and enhance the generally cool colours of a landscape.

Practise painting figures directly with a brush, as in illustration 44. Concentrate on the pose and a sense of movement: ignore details such as hands and feet! Also, spend a little time now and again observing people, perhaps in a shopping centre or railway station, and making quick sketches of them in your sketchbook. In this way you will gain some confidence in capturing the essential characteristics of figures and learn how to set these down quickly. See also illustrations 19, 29 and 32 and plate 12.

44 Simple brush-drawn figures

Skies

The character of the sky will establish a mood for the whole painting. Indeed, some landscape paintings are predominantly skyscapes with just a trace of land. Additionally, the sky determines the quality and distribution of light throughout the painting and influences the colour key.

Skies have no clearly defined shapes and hard edges so they can be difficult to paint, especially where large areas are concerned. Like most aspects of watercolour painting, confidence is the key; this comes from practice and the willingness to experiment. Generally, skies have to be completed in one 'take', and can be modified and developed only while the paint is still damp – once a sky is dry, leave well alone.

Here are some sky techniques to try out.

- Skies are seldom bright blue all over. As an introduction to painting skies try mixing a few suitable colour washes. You could start with cobalt, ultramarine or cerulean blue but modify these colours by adding a little burnt umber, raw sienna, Payne's grey and so on. Experiment to see what colour mixes will suggest a wintry sky, a sunny sky, a stormy sky and other moods and characteristics.
- For the sort of sky shown in illustration 45 work on damp paper applying a general wash with sweeps of the brush. Use a large flat brush. You can see that I have applied these sweeping strokes of colour working from the bottom right towards the top left. Working quickly, blot the bottom section of the sky with some tissue paper. Use a similar technique to create soft outlines for the cloud formations. Notice that, in general, skies are palest at the horizon.
- For the effect in illustration 46 I have worked into the initial wet wash using a large, round pointed brush on its side. Keep the brush dry by wiping it on some tissue paper. In this way you can lift out paler areas and modify other parts into cloud formations. Notice how a strong contrast between a light horizon and deep cloud tones will create a dramatic effect.

45 Sky study using wet-in-wet and blotting-out techniques

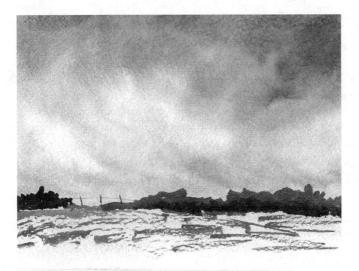

46 Sky study using lifting-out technique

- You can also use a wet-in-wet approach. Dampen the paper and then lay in the colours you want, allowing them to diffuse into the surrounding area. While the paint is still wet you can add a little more colour to some areas to suggest the density of the clouds.
- For a more controlled effect use a flat wash brush charged with just enough paint to allow you to apply the colour in a fairly dry state. By varying the pressure on the brush you can balance solid patches of colour with lighter tones and softer edges. Build up the strength of colour in some parts by adding to the still wet wash and contrast these with light areas left as white paper.

These are just a few ways of painting a sky. Experiment and try other methods of your own.

Foregrounds

With some landscape ideas the main problem is deciding what to do with the foreground. If this is just left as a large area of flat wash then obviously the painting will lack interest and impact.

In general, landscape subjects have to be simplified in composition and not treated too literally or fussily when it comes to detail. However, a feature such as an old farm building, a storm-stricken oak or some foreground grasses and flowers will provide a useful point of interest in the painting and offer a contrast both in subject matter and scale. Used discerningly, foreground details will prove particularly helpful in leading the eye into the picture and adding to the sense of space and distance.

Try to make a collection of suitable little studies and details in your sketchbook. These can be of anything which could be added to give a focus of attention in a painting – crumbly stone walls, gateways, animals and birds, trees and so on! An alternative is to treat the foreground in a textural way, as in illustration 47. Here I have used a variety of brushwork and other effects, including masking out and gouache.

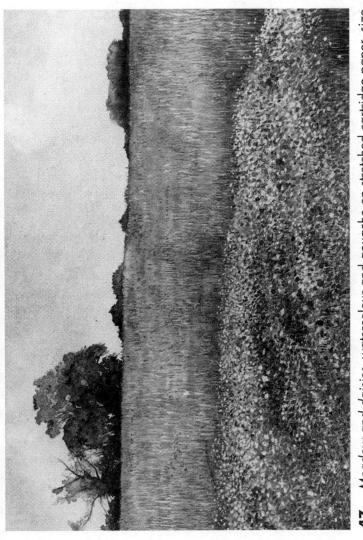

Meadow and daisies, watercolour and gouache on stretched cartridge paper, size 25 x 35cm

Projects

- 1 Paint a couple of simple landscapes (see illustrations 45 and 46) but with different sky effects. Try to convey a particular mood through the way that you paint each sky.
- 2 Think of a nearby landscape area that appeals to you and devote a whole day to an 'on location' painting. To make the most of your time out and about ensure that you are well prepared. Consider what you need to take in the way of equipment and carefully plan the work you aim to do.

Start with a few quick sketches to get a feeling for the subject and decide on the best viewpoint and composition. Remember the points about distance, mood, skies and foregrounds discussed in this chapter. For the painting, work on A3 paper or larger and keep the approach fairly broad and unfussy.

Later, indoors, you may like to try another version of your landscape, working from the sketches and location painting. For this painting, take more time and add a little more interest and detail.

PAINTING FROM SKETCHES, DRAWINGS AND PHOTOGRAPHS

You may not always wish or be able to work from direct observation and instead you might decide to develop an idea from a range of sketches, drawings, photographs and similar resource material. When this is so, try to give yourself plenty of information to refer to. While you can, of course, work from memory and imagination as well as the sketches: you will still need enough research and reference material to prompt ideas, help you with the basic composition, and preferably indicate the general distribution of colour.

Sometimes you will want to go out and sketch with the specific intention of collecting this sort of information – so that, once back at home, you can use it to paint a well resolved watercolour. On these occasions, bear in mind that you won't necessarily be making fine looking sketches, but rather you will need to note down the qualities, characteristics and other things about the subject that will help you create a painting. Chapter 6, *Keeping a Sketchbook*, has advice on the different techniques and approaches to use.

You can use your sketches and photographs in the following way:

- Assemble all the relevant sketches and photographs and look through them. If possible, spread them out so that you can make an overall assessment of the information they contain. Decide which features and qualities you would like to incorporate into your painting. It could be based primarily on one sketch plus references taken from others, or it could be a compilation from various sources.
- Now think about the composition of your painting. Use your sketchbook for a sequence of small roughs to plan the design.
- When you think you are satisfied with the composition, look at each part in turn, consider how it will enlarge and how

you are going to paint it. Will the composition create some interest and impact? If required, look at page 100 for further advice on this. If some areas look empty and unexciting, do you need to go back and collect some more reference information?

- Using the advice below, from your final composition sketch enlarge the idea to fit the painting paper.
- Now work through the general stages of painting outlined in Chapter 7, referring to your sketches and photographs for ideas and information.
- A sequence of sketches and photographs on a particular theme may provide ideas for more than one painting. Try a different emphasis, viewpoint or composition, perhaps changing the scale or shape of the picture.

Enlarging and developing ideas

If your intention is to work from an individual sketch and paint a larger, more resolved picture from it, the first thing to do is to ensure that the painting paper is in proportion to the original idea. Place the sketch on the larger sheet of paper so that its bottom edge and left-hand side are aligned exactly with those of the big sheet. Now place a straight-edge diagonally across the sketch from bottom left to top right. Any rectangle constructed with its top right-hand corner on the extended diagonal will be in proportion to the sketch.

Normally, you won't need to enlarge a rough idea accurately, although you will want to get the general shapes and proportions approximately correct. The quickest method is to use faint guide lines drawn diagonally as well as to divide the paper in half in each direction. Do this both on the sketch and the painting paper. Looking at the sketch you can see where the main lines and shapes of the composition come in relation to these guide lines and so match them to the corresponding positions on the large sheet. If you do not want to damage the sketch, cover it with tracing paper before drawing in the guide lines.

For greater accuracy, use the squaring-up method shown in illustrations 48 and 49. Draw a grid of squares over the original sketch (or on the tracing paper covering it). Avoid a large number of squares as this will only

48 Squaring-up a sketch ready for enlarging

complicate the process. Draw a faint grid on the painting paper which uses the same number of squares in each direction. Now, referring to the original sketch, take each square in turn and redraw the main outlines appropriately larger to fit the corresponding square on the larger sheet of paper. Continue the process until you have completed the enlarged outline, then carefully erase the guide lines.

49 Outline drawing made on a squared-up sheet of paper

Using photographs

Photographs can make valuable specific or supplementary reference material. However, it is always wise to exercise some care in how they are used. Try to work *from* them rather than copying them, and never rely on photographs as your only source of inspiration and reference. Indeed, there are many artists who totally reject the idea of using second-hand imagery of this sort. In contrast, there are those who justify the projection of a transparency on to a sheet of paper so that they can draw round the outlines. There is probably a happy compromise!

As you have already seen, photographs can provide excellent supporting information when used in conjunction with sketches and other research drawings. They will instantly enable you to explore and record different viewpoints and composition ideas, for example, or capture the exact detail of something which you certainly wouldn't have time to complete when sketching outdoors. There may even be occasions when a section of a photograph could be copied – in part of a painting where you need the exact detail of something, for example. But, in general, photographs are aids, starting points and additional reference.

There are two good reasons why you should not directly copy a photograph. The first is that paintings always benefit from a degree of spontaneity and originality. In some ways painting is like solving a problem – you shouldn't know all the answers before you start! There must be an element of discovery in the painting process, for this is what keeps it lively and interesting. Simply reworking an idea from a photograph is likely to result in a dull picture, however technically sound it may be.

Second, photographs are not the unequivocal portrayers of truth that we believe them to be. They usually distort distance and perspective and therefore it is difficult to translate something such as a view down a street, into a convincing painting. Naturally the quality of your camera and your photography skills will make a difference, but even so you will notice that in many photographs the vertical lines tilt inwards and the perspective of buildings and similar objects is exaggerated. Similarly, colours cannot be relied upon: they are approximate to say the least.

Whenever you use photographs, try to ensure that they are your own. If you took them it means that you have witnessed the actual scene or subject and consequently can also work from your recalled impressions and feeling about it. Remember that in painting you are never aiming to recreate a photograph. Instead you are concerned with paint and painting techniques and should be sensitive to these.

Photographs may be useful for:

- Supplementary reference to provide a general eminder of the subject or a piece of specific information which you can use in part of your painting.
- Starting points as the basis of an idea which you can develop or interpret in your own way. There are many ways photographs can be useful as starting points for studying tone and shape or developing a selective or abstract result.
- Fleeting moments for action subjects such as a galloping horse or someone windsurfing which you simply would not have time to sketch in any detail.
- Composition aids to give you different viewpoints and ideas from which to design your painting.

Consider the information below as you study illustrations 50 and 51. Then complete the projects listed at the end of this chapter.

As you can see, I have painted the picture of moored boats (illustration 51) from the photograph shown in illustration 50. This was an interesting subject that I came across when out walking one day and, as I had my camera with me, I thought I would take one or two photographs of it for possible future use. While it would have been helpful to have made a quick sketch, it is in fact a complicated subject and thus I would have taken some reference photographs in any case.

This is the type of subject matter where the success of the painting depends on the strength and accuracy of the initial drawing. There are lots of straight edges and particular shapes which must be drawn with some precision if the overall result is going to look convincing. Because of this, I began by making a careful outline drawing to work from. This was made on a separate sheet of cartridge paper (approximately A3 size), so that I could erase lines and alter shapes as necessary, and then traced on to the painting paper. I used a sheet of stretched, heavy-quality cartridge paper to paint on, as I knew this would allow me to achieve the mostly flat areas of colour and well-defined edges required for this subject.

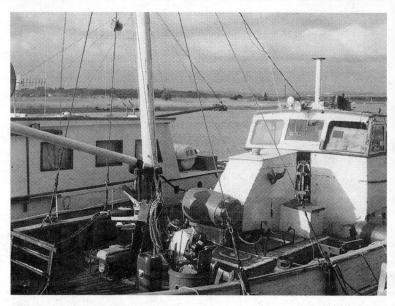

50 Reference photograph

From the composition point of view you will notice that I have reproduced the information in the photograph very much as it is, except that I have simplified some areas (principally the background) and left one or two things out where I thought this would aid the design.

I started at the top of the painting with the sky and sea area, keeping these as broad sweeps of colour, and in the main worked methodically down to the foreground area. Several of the shapes are painted with single flat washes of colour, with these requiring an additional wash only where there were shadows. By working in this way I could overlap foreground shapes against those behind and so create the necessary degree of definition and feeling of space. The ropes were painted in last of all, with a long-haired, round no. 4 sable brush and a rigger for the fine lines.

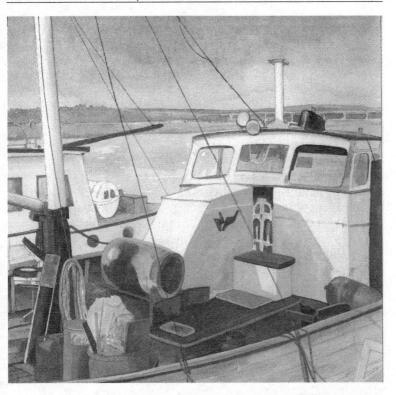

Painting made from the reference photograph (illustration 50)

Projects

- 1 Choose a holiday photograph as the main reference idea for a water-colour painting. Decide how literally you want to interpret the photograph and whether some parts should be simplified, exaggerated and so on. Consider carefully the composition maybe it would be better to concentrate on just part of the photograph. Start with an outline drawing of the principal shapes and work through the stages explained in Chapter 7.
- 2 Make a series of on-the-spot sketches on the theme of reflections in water. The reflections could be in a lake, a river, an ornamental pond and so on. Use your sketches as the reference material for a painting, taking note of the information in this chapter and also Chapters 6 and 7.

USING YOUR IMAGINATION

You have probably noticed that all the ideas and projects you have been asked to consider so far have been based on observation, with the aim of depicting a faithful representation of what is before you. This is because working from observation is not only important in training you how to look at, assess and understand things, it also helps in the way that you learn and apply different painting techniques. These skills in observation and techniques will provide you with a sound basis from which to develop your watercolour painting.

You may think that working from observation inhibits real freedom and interpretation in your paintings. It need not, of course. For one thing observation need only be a starting point – you can expand and develop away from any initial idea. Additionally, like all artists, you can select and emphasise, focusing on what to you seem the most significant elements of the subject matter. Essentially, painting is a way of expressing your personal reactions and feelings about your surroundings or whatever other themes and subjects impress and interest you. Look at the pictures in any large gallery: it is soon apparent that there is an infinite variety of styles and approaches even when artists are concerned with quite ordinary subject matter painted from observation.

Now that you have covered the basic techniques and practised these through a number of different exercises and projects, you are in a position to start choosing your own subjects to paint. Quite probably some of the paintings you have already completed will have been much more successful than others and these will tempt you in a certain direction, towards specific subjects and ideas. By all means build on your success, for this will engender confidence and, in turn, motivation. The more you paint, the better you will become!

Sometimes you will come across a subject that immediately excites you, perhaps because of its colour, its strong sense of composition, the play

of light and dark, a particular mood, or some other quality. Capitalise on such ideas; paint them straight away. On other occasions you will have more time to consider what to paint. Choose carefully. Each new painting should be slightly more difficult than the last. If you merely stick to well tried-and-tested ideas rather than challenge your abilities there will be no chance to develop and improve. Be adventurous and ambitious and don't be afraid to try out different themes and techniques. Now let's have a look at some ways in which observation can be combined with imagination.

Experimenting with techniques

Many people assume that the greatest impact and interest in a picture is created by the subject matter, whether this is a landscape view, a still-life group, a flower study, someone's portrait, or whatever. In fact, the way you use colour and apply paint can be just as important. Indeed, sometimes the subject matter is secondary to other elements, and it may be the imaginative use of technique or the interaction of a combination of techniques which is the actual source of interest in the painting.

In any event, success in how you interpret a chosen idea will, at least in part, depend on using the most appropriate techniques. So, when you are making preliminary sketches or considering how best to tackle a particular subject, give some careful thought to the kind of surface qualities and effects you need in different parts of the composition and which techniques will suggest these most convincingly. Again, don't just use those methods which you can guarantee will work. As we have seen, watercolour is a medium in which some techniques, such as wet-in-wet, embrace an element of chance. However, we mustn't fight shy of using such techniques because they are risky, for it is that very quality which can produce some surprisingly exciting results.

Some subjects actually invite a loose, experimental use of techniques. When you are painting a large sky area, for example, it is necessary to work quickly, run one colour into the next before any edges dry, and to use a certain amount of imagination. What about a textured surface, such as a pebbly beach? You might decide to try a wax-resist method here. Similarly, if you were painting a general garden view, the distant patches of flowers might best be interpreted as vague blushes of colour. It is worth trying a few ideas like these, and others, perhaps where there is a

dramatic lighting effect or a special kind of mood and atmosphere. Subjects like these will encourage you to work in a freer way, rely more on your personal thoughts and impressions, use your imagination, and experiment with techniques.

Working from memory

Your landscape, street scene, interior, wildlife picture and so on doesn't have to be painted from life or sketches, photographs and other reference material. It can be composed entirely from memory and imagination. Assuming you want such paintings to look realistic, this sort of knowledge and skill will take some while to acquire. The best way to train your memory and develop a good visual vocabulary is to observe and sketch things as much as you can. In particular, try to master the art of the quick sketch: the ability to jot down in four or five minutes the salient structure and features of subjects. In fact, this is just the sort of technique you will need to use to bring ideas to life when you draw them from memory.

You will probably need to rely on your memory to some extent even when you are working from sketches and photographs. This type of material seldom contains all the references and details required to create the final painting and therefore you may have to use a certain amount of invention, experience and memorised information as well. Also, the limited amount of time will usually prevent you completing sketches as thoroughly as you might wish. Any follow-up paintings will therefore be worked from a combination of observed facts, notes and other reference matter, and what can be remembered.

Additionally, you might like to develop some paintings directly from memory. These can be based on events and experiences recalled from the past – anything that you think would make an interesting painting. Commit your ideas to paper in the form of quick outline sketches to begin with, and then see how they will gel into an overall composition. Make various design roughs until you are happy with the basic content and layout. When you set to work on the painting you may want to find some photographic references in books and magazines to help you with particular shapes and details, or possibly you will prefer to make your own reference drawings from actual objects. Alternatively, you may feel confident enough to proceed immediately with the painting and work entirely from memory.

Fantasy and imagination

Some artists find their inspiration in the realms of dreams, fantasy and make-believe. Instead of painting with the aim of representing objects, scenes and events in the real world, they prefer to rely on their powers of imagination and invention. As you develop greater skills in drawing and become more confident with different watercolour techniques perhaps you will find that this is the type of subject matter you would like to explore.

You might think it would be quite easy to work with imagery that was derived from fantasy rather then fact, for who's to say that shapes and forms created from your own imagination look wrong? However, sometimes such pictures can seem unconvincing and this is usually because the idea has grown from a collection of interesting individual shapes without a concern for the whole composition, or because certain invented objects and forms lack an assurance in the way that they are drawn or are simply too weird-looking to be acceptable.

Actually, success with imaginative pictures often depends on a knowledge of traditional and formal approaches to painting and basic drawing skills. If, for example, you wanted to convey a grossly exaggerated sense of space in such a painting, then you would need to call upon your understanding of perspective, colour theory and related matters in order to achieve it. What's more, the subject matter might well be evolved through a process of distorting images from the real world. The implication here is that if your starting point is reality, then you must first be able to draw reality. So, there are no excuses for not keeping a sketchbook, even with fantasy art!

Where else can ideas come from? Poems can provoke a highly personal response, as can sequences or general themes from plays, novels, songs and so on. Indeed, if you like the idea of a narrative picture, why not invent your own story-line? Also, although you don't remember every dream in much detail, sometimes you may have a vivid recollection of at least part of a dream which, when embroidered with some imagination, will make a good starting point for a painting. Other ideas might come from looking at the work of different artists, particularly visionary, symbolist and surrealist painters like William Blake, Gustave Moreau, Odilon Redon and Salvador Dali. Magazines, posters and

books can also prove useful, especially with regard to unusual techniques and how to convey qualities such as fear, mystery and dramatic viewpoints. Keep a scrapbook of postcards and cuttings which could be helpful.

As a way of exploring fantasy art try these two ideas:

- Paint a landscape, interior or still-life picture in the normal way but include in it one item which is completely incongruous. Use your imagination to think of something which is absurdly different from the rest of the composition.
 - Again, work from a real-life theme but this time totally change the colours. You could, for example, replace every colour with its complementary, or simply select colours at random.

Creating abstracts

Most people find it far easier to appreciate and enjoy representational and figurative painting than a work which is abstract. Naturally, they readily identify with pictures of landscapes, people, flowers and so on, rather than those which are composed of seemingly indiscriminate shapes and colours. In fact, fundamentally, all paintings are simply an arrangement of different marks and colours, although the general belief is that these should mean something and that what they depict should relate to our everyday visual experience and understanding. In the main, we expect paintings to be descriptive and pictorial and we want to see these qualities conveyed with recognisable skill.

Your study of painting should be catholic and wide ranging, for not only will this give you a much broader experience from which to develop your own work, it will also mean that you can reject techniques, styles and philosophies from an informed standpoint rather than one of ignorance. A close study of abstract paintings, for example, will show that quite often the results are evolved from an intellectual, investigative or analytical approach which may well start with a reference to actual objects. Not all abstract paintings are merely a collection of careless lines and random marks!

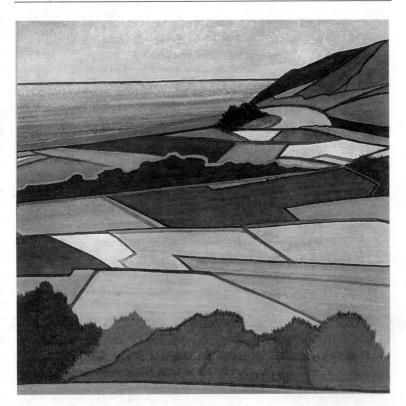

52 Abstracted coastal landscape view

There are two main methods of developing an abstract painting. The first, as I have just indicated, is inspired by traditional subject matter, although interpreted through abstract means, as in illustration 52, and the second is to concentrate on the formal elements of picture making, perhaps exploiting colour relationships, different surface effects, the properties and possibilities of the medium, and so on, as in illustration 53.

The first method, abstracting from nature, usually involves a process of selection and simplification. You can carry this process as far as you like. For instance, it could be that all you decide to do is leave out some objects from a landscape view in order to create a more dramatic

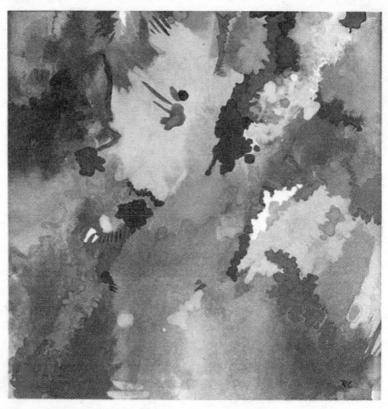

53 Abstract expressionist watercolour

composition, or you might use a restricted palette, or simplify some of the shapes. Alternatively, if you work through several stages of simplifying the subject matter, you can appreciate that you will finish with a few bold shapes that bear no direct resemblance to the originals. Only you know that you started by looking at a still life, portrait, landscape or whatever – you have created an abstract painting.

In illustration 52 I have simplified a coastal landscape view into bold shapes and flat areas of colour. Try a similar painting for yourself. It will get you thinking in terms of broad shapes and basic design rather than unnecessary detail and you could also apply some colour theory techniques to it. Think of other ways which might lead to an abstract or

semi-abstract result – perhaps by working in monochrome (tones of one colour), or using a distinct emphasis or distortion in the composition. Sometimes, too, it is good to work on a large scale and in a completely free and uninhibited way, using only colours and techniques to express a feeling, mood or other abstract quality.

Projects

- 1 Develop a painting on the theme of 'Large and Small'. Aim to express this theme in a personal and individual way. You could work from observation simplifying, exaggerating or distorting what you see or you could evolve your idea entirely from imagination.
- 2 Choose a small, quick sketch in your sketchbook as the starting point for a watercolour painting. Use your memory and imagination to add more information and interest to the painting.
- 3 Choose four or five contrasting objects from around the house and arrange them in a still-life group. Find objects which have different shapes, colours and textures. Give some thought to the composition of the group, which will need to be arranged on a table about 6 feet or 2 metres from where you will be working. The lighting is also important: try to ensure that there is a strong light source from one side. Use an angle-poise lamp or table lamp to accentuate the lighting, if necessary.

Now draw the objects in terms of a series of tonal shapes. Try not to be too conscious of what the object is or its particular outline. Instead, try to see it as composed of juxtaposed areas of tone – patches of slightly differing colours which have resulted from the play of light. You may need to generalise or simplify what you see but you should be able to build up a kind of semi-abstract interpretation of the still-life in this way. Your drawing will fragment the overall shapes of the objects and background and you can then paint in the new shapes you have discovered. Refer to the actual colour but keep to flat areas rather than blended or modelled colour.

12 DEVELOPING YOUR ABILITY

Now that you have studied and practised all the basics, from a knowledge of materials and colour to a familiarity with different techniques and processes, you will want to try out your own ideas and start to evolve a personal way of painting. While you have been working through the previous chapters you will no doubt have been impressed by the fact that watercolour painting offers tremendous scope for individual interpretation. Moreover, there are always new ideas to explore and fresh things to learn or discover and this is what will keep your painting lively and developing.

You will probably already have come across particular techniques and certain types of subject matter which interest you more than others. These will provide you with a good starting point, an initial direction to explore. To succeed in painting ever-improving pictures you must resolve to practise and persevere, have a willingness to experiment and confront new ideas, and find the determination to tackle problems as they occur. Don't be too disheartened by failures – all artists have these. Learn from your mistakes and, in you painting journey of discovery, travel optimistically. The next painting will always be the best!

No matter which direction you take, your foundation skills will be important. Don't neglect them, but rather, through sketching, experimentation and deliberate practice, aim to improve such skills. You may be among the many artists who value traditional skills and techniques as the focus of your work. Alternatively, your approach may gradually move away from formal elements and the reliance on objective study and representational outcome, and instead become more expressive, subjective or even abstract in result. Even here, basic skills remain essential.

Looking at other paintings

Don't be tempted into methodical painting, by which I mean restricting yourself to a well-tested theme and a set way of painting it. This will inevitably lead to rather unexciting results and it certainly won't help you improve. Aim instead for a breadth of experience which, contrastingly, will introduce you to a wealth of different ideas and possibilities. If you are always searching, and hopefully sometimes discovering, your work will remain lively and forward-looking.

Another way of adding to your breadth of understanding and appreciation of watercolour painting is to study the work of other artists. Not only is this enjoyable, perhaps even inspirational at times, but it is also an excellent way of learning about selecting ideas, using techniques and mounting and framing your watercolours. Look at a wide range of work – paintings by your friends as well as those of the great masters. Visit exhibitions, galleries and museums. Visit your local art gallery or museum: many provincial galleries are surprisingly well-endowed with watercolours and indeed may have enough space only to display a selection. Go to art society exhibitions, and aim to see at least a few well-known watercolours at the major galleries such as the Victoria and Albert Museum and the British Museum in London. Start your own collection of postcards, reproductions, cuttings and books as a source of reference, information and inspiration.

Compare the two paintings shown in illustrations 54 and 55. Notice how the watercolour medium will adapt to different circumstances. In illustration 54 the painting is worked from the actual subject matter and sketches, using to some extent a subjective and painterly approach. Yet the medium is equally successful when used in a more illustrative way, as in illustration 55.

Learning from experience

In any painting, even when you have planned the idea carefully, you can never be sure what is going to happen once you have applied those initial washes of colour. Every painting is, as it were, an initial mystery and an eventual revelation; this is exactly how it should be. What you find out during the painting process might be something about the subject

54 Using watercolour in a subjective, painterly way

matter, the use of colour, the method or medium – suggesting a certain quality of light, conveying a sense of mood and atmosphere, and so on. Although such discoveries may seem small in themselves, each one will add to your wider knowledge and skills.

Consequently, the more you paint, the more you will find out and learn. Try to build on this experience and carry forward what you have learned into the next painting. If you come across a particularly difficult problem, then take a break from the main piece of work while you practise the technique, colour mix or whatever on another sheet of paper. Return to the actual painting when your confidence is restored. As you know, most watercolour papers will not stand up to a lot of lifting out, erasing and alteration of the painted surface. So whenever possible you need to be positive and speedy in the way that washes are laid in and the different paint effects established. Any revision in the way that a certain area has been painted must be carefully considered and, as necessary, practised separately rather than spoiling the actual painting.

You may wish to record some 'discoveries' in your sketchbook or notebook – perhaps, for example, when you have created a particularly

55 Using watercolour in an illustrative way

interesting colour mix, or invented an effective way of suggesting an unusual texture or detail. You can then refer to your notes and sketches when you come across a similar problem in the future. Also, this sort of information will sometimes stimulate other ideas to investigate and incorporate into your paintings.

A personal style

In time you will begin to develop an individual style and make the sort of paintings which truly reflect your ideas and feelings. Style is the distinctive or characteristic way of working which identifies a particular artist. In a sense it is an overall signature. When you look at a painting by John Cotman or David Cox for example, (see Chapter 1 and plates 1 and 2) there is no need to try to decipher the name in the corner, for their style is immediately recognisable.

Usually, artists do not set out to create a certain style. It is something which gradually evolves. Your style will be determined by a number of factors – the way you mix and apply paint, the techniques you like to use, your subject matter, and your own personality and how you react to things. One of these factors often dominates. Your paintings may be instantly recognised because of the colours you normally choose, for example, or the fact that you prefer to work mostly in a loose, wet-inwet style. As you pursue certain subjects, and as you develop particular effects and paint with increasing freedom and confidence, your personal style will emerge.

Evaluation

You will find painting an absorbing and rewarding activity. I suppose it can be a form of escapism and maybe for that reason it can be relaxing, but it is not easy. The best artists succeed because they are never complacent and not afraid of self-criticism. In fact, as you will now appreciate, the painting process is one in which you have to constantly make judgements. All the time you need to question whether, for instance, a wash is too strong, a shadow too dark, a shape too big.

At the end of every painting it is a good idea to spend a few minutes looking at the result and assessing its success. Does it fulfil your intentions? If it is a location sketch, does it provide enough information to work from? If it is the main painting, have you achieved the sort of feeling, effects and impact that you were aiming for? What are its strengths? Where could you have done better?

Additionally, keep an eye on your general progress and development by periodically devoting some time to an overall evaluation of your work.

Spread out or display ten or more recent paintings and try to make an objective assessment of how you are doing. By looking at a range of work you will be able to make a better judgement about weaknesses in technique and the sort of things you should be practising more, as well as the strengths and interests you should be building on. This kind of evaluation helps in making decisions about the future direction of your work and the particular aspects on which you should be concentrating.

Don't depress yourself with over-zealous self-criticism. Instead, try to justify any weaknesses or faults you find and decide on positive remedies. You may feel that more practice will help, or perhaps the answer lies in seeking further instruction, information or advice from books, videos or courses. Some suggestions are listed in *Further Reading and Resources* at the back of this book. It's also useful to hear what other people think of your work. If you know other artists, you could get together for a shared evaluation session. Alternatively, join an art society or club, or enrol on a painting course. These will provide opportunities to meet fellow artists, both amateur and professional, and to exchange views and ideas.

Projects

- 1 Watercolours are extremely popular for landscapes and for painting well-known landmarks and places of interest. Next time you have the opportunity, look at the paintings in your nearest commercial gallery. These will most likely include some watercolours of distinctive local beauty spots, archaeological features, or buildings of historic or architectural interest. Study these and evaluate their success, both from the technical point of view and with respect to creating an interesting painting using some individuality of style.
 - Next, make a painting of a well-known place or building in your locality. Work from location sketches supported by photographs for the necessary details, or paint on the spot if you wish. Make use of any ideas or aspects of technique that you may have gleaned from your gallery visit.
- 2 Make an evaluation of your last ten paintings. Can you detect a progression and improvement? Perhaps also you can see an emerging style? In your notebook or sketchbook, jot down any obvious weaknesses and suggested remedies.

FRAMING AND DISPLAYING YOUR PAINTINGS

Like most artists you may well find that you are seldom entirely satisfied with a finished painting. In some ways this is a good thing, for it will encourage you to address any particular problems of technique and strive for even better results. Even if the final picture isn't always quite what you had hoped for, the process involved in painting it will have reinforced certain techniques and added to your general experience. Most paintings teach us something, however small, and what we learn can be subsequently developed and perfected as we paint more and more pictures.

Further, many paintings are tackled with the express intention of finding out something about an individual technique or looking at ways of creating specific effects, rather than necessarily achieving a perfect and well-resolved result. Indeed, some paintings will be sketches, preliminaries or investigative works, perhaps with the principal intention being just to note down an idea for future reference. However, as your watercolours improve and you make some paintings which are particularly successful, you will want to mount and frame a few. Hang them in your own home or submit some for display in a local open exhibition, which will also give you the opportunity to meet other artists and discuss their work. Painting, after all, is a means of communicating your ideas to other people, so your work should be seen. Again, it is encouraging to see some of your paintings on display, and this will also help you to notice how your work is developing and improving and spur you on to even greater things!

The purpose of framing

There are two main reasons for framing: first, to provide a means of presenting and protecting the watercolour; and second, to complement, enhance or enliven the work. Consequently there are both practical and aesthetic considerations to assess when framing a painting.

Watercolours should be framed under glass, usually with a fairly wide, unpretentious mount. Look for a mount and a frame that work well together, providing a space around the picture which helps to focus attention on the work itself. There is no doubt that the type of framing and presentation can significantly influence people's response to a painting. A good test of this is when viewing an exhibition or visiting an art gallery. You will notice that some pictures attract your attention more than others. Obviously the content and style of the picture is important, but often it is the framing which plays a decisive role in guiding our interest into the painting.

Many artists opt for safe, simple and subtle frames and mounts, but this isn't always the best solution. Framing can be interesting and adventurous without necessarily detracting from the artwork. You should try to avoid keeping to one framing method that seems to work with your pictures and, as a result, framing everything in the same way. Bear in mind that there is no 'proper' way of framing: in the end it is a matter for personal taste and judgement. However, your choice should be informed by a consideration of various factors such as colour, proportions and the available types of mouldings and mountboards. Look at some galleries and exhibitions to see how other artists have framed their watercolours, and to get ideas for your own work.

Often in the past, framed watercolours have suffered some damage because inferior boards, tapes and adhesives have been used. These have contained acids which have gradually leached out over the years, discolouring and spoiling the painting. Even today the less expensive types of mountboard, framer's tape and so on contain acids. So, if you wish to preserve your paintings for posterity and make a really good job of framing them, use conservation-quality materials. If you decide to do your own mounting and framing, use a wheat starch powder or water-soluble PVA adhesive, both of which have a neutral pH value. Look for mount-board and other materials with a low pH value or are acid-neutral.

Choosing mounts

There are three main points to consider when choosing a mount: the colour; the size and proportions (depth of margins); and the type of mount (whether it should be cut from textured board, a double mount, washlined and so on).

Colour

The most frequent dilemma is whether to play safe and select a coloured mountboard that echoes one of the principal tones in the painting, or to choose something quite contrasting. As a general guide, the colour of the mount should reflect the basic neutral colouring in the picture. Consequently, creams, greys and weak blues are often the most sympathetic choice.

Usually a light-coloured mount will provide a suitable breathing space around the painting and in a sense open it up, whereas a dark mount will close the image in and provide a dramatic contrast. A positive, strongly coloured surround will sometimes lift the colour key in the artwork and add to the mood and atmosphere of the picture. This may be a factor, for example, when choosing the mountboard colour for a dramatic land-scape.

Remember that there is a practical purpose for the mount. Watercolours will soon deteriorate if they are placed in direct contact with glass. Apart from the fact that any such contact might smudge or disturb the surface pigment of the work, an air space is necessary between picture and glass to prevent the build up of condensation and possibly subsequent damage through foxing (small brown spots caused by dampness). Therefore, as well as creating an aesthetically pleasing border to the painting, the mount acts as a suitable buffer between the artwork and its protective glass covering.

Scale and proportions

The next decision concerns the width of the margins around the mount. If these are too wide, then the mount will dominate the picture, whereas if the margins are too narrow the effect simply looks mean and, once again, the emphasis is inadvertently concentrated on the mount rather than the painting. Just as it is interesting to experiment with different mountboard colours and notice how each one creates a fresh look to the

picture, so it is worth testing possible margin and framing widths. Do this with some offcuts or samples of mountboard, which you should be able to obtain from a framing shop.

There is no hard and fast rule about the proportions of borders relative to the size of the image, although generally a small image looks better with a relatively wide mount. For some watercolours a mount with equal margins will seem right, although for the majority you will find that a mount with a slightly wider margin at the bottom is more pleasing. As a guide, an A3 landscape will need margins of about $2^{1}/2$ in or 65 mm, with 3 in or 75 mm at the bottom. Sometimes the width of the moulding (framing wood) will influence the sort of margins to use in the mount. The overall effect of mount and moulding has to be considered, so that, for example, if a wide moulding is used then, in consequence, the mount might need to be of narrower proportions.

Type of mount

With a small investment in the right equipment and a little practise it is quite easy to make your own mounts, but you must be sure that they are neatly and precisely cut, for overcuts and inaccuracies immediately show up and can become a positive distraction when viewing a painting. Mounts depend on accurate measuring, clean, straight lines, and exact right-angles. As you handle and measure the card, be careful not to mark or damage it in any way.

Cutting window mounts

You can cut a simple window mount with a sharp craft knife used against a metal straight-edge. First, check the size of the painted image and decide on the width of margins required around it. Remember that the mount will tend to overlap slightly on the painting. Cut a sheet of mountboard to suit the overall dimensions (picture area plus mount margins). You can mark off the margins on the back and then cut out the centre piece, or work from the front, which in my experience gives a neater result. If you decide to work from the front, mark off the width of the side margins with faint pencil dots along the top and bottom edges, then place a perspex rule across the card and mark the actual corners of the central aperture with a pin. Cut out the centre shape using a sharp craft knife against a metal rule, working on a cutting mat or similar suitable backing.

This method is fine for simple, right-angled cut mounts but you may wish to use mounts with bevelled 45° cuts along the edges. In this case, and especially if you are going to make a lot of mounts, you will need to buy a mount cutter. Various mount cutting sets are available from art shops. As with all art materials and equipment it is worth buying the best you can afford: ask for a demonstration. Practise on some card offcuts before attempting to cut an actual mount. The main difficulty is where the cuts meet at the corners, but again this is mainly a question of practise. Use acid-free framer's tape to fix the painting to the back of the mount.

Double mounts and other effects

Many watercolours benefit from the use of a double mount. This usually has a narrow inner strip (perhaps measuring between 1/4 in to 1/2 in or 5 to 10 mm) of a slightly contrasting colour to the main outer border. Similarly, a stepped effect, using the same coloured mountboard for both inner and outer mounts, can look interesting. Double mounts often give a more pleasing and professional look and another advantage is that the narrow inner mount will form a useful defining and unifying edge to the painting. This creates the opportunity to use a bolder colour for the inner mount, while reflecting one of the general tones of the picture in the outer mount.

If you lack the time, confidence or equipment to have a go at making your own mounts, then discuss any ideas for mounting and framing your watercolours with professional framers. They may stock ready-cut mounts and will be able to make other mounts to your exact requirements and advise on a variety of alternative mount-making techniques. For example, you may want to present the work in an oval format; embellish the mount with wash lining, gilded lines or other decorative techniques; use mounts which include impressed lines; or opt for a composite mount (various bands of tones or colours cut in order to interlock into a single, flat mount).

Backing watercolours

The way that a watercolour is presented is a matter of personal preference. In most cases, watercolours are not glued to a backing support but allowed to hang naturally. This means that there may be

some slight surface undulations, especially with larger pictures. However, paintings made on thin paper may need backing before fixing them to a mount, for undue buckling of the picture surface will distort the effect of light on the image, making it difficult to view it properly.

A watercolour can be flattened and strengthened by gluing it on to a sheet of backing card. Choose an acid-neutral type card and use a wheat starch powder or water-soluble PVA adhesive, both of which have a neutral pH value. Cut the card to the frame size, outline the position of the painting, apply a thin, even coating of adhesive to the card and carefully lower the painting in place. Working quickly from the centre, smooth out the image towards the edges by pressing down on offcuts of clean paper. Leave the painting to dry under pressure – the weight of several drawing boards or some heavy books is ideal.

Choosing frames

Like mounts, frames need to be well made and carefully chosen if they are to complement the painting to the best effect. Frames should provide a positive edge to the work, but without being too conspicuous. The same principles apply as for selecting coloured mounts. For example, the colour of the frames or moulding could repeat or enhance one of the general colours in the painting. Moulding and mount have to work together and must be assessed as a combination in relation to the particular painting to be framed. Most watercolours look best with a narrow, fairly unpretentious natural wood, lightly stained, or colourwash frame, see illustration 56.

Again, framing ideas can come from viewing exhibitions, and framing advice from a reputable framer.

Making frames

You may be interested in buying all the necessary equipment and making your own frames. Bear in mind that the cost of reasonable equipment will probably be several hundred pounds and that consequently such an investment must be viewed against the likely number of frames you will make. The benefit of making your own frames is that you can produce something exactly to your particular specifications and have the

68 Framing materials and equipment

satisfaction of having created both picture and frame. In addition to some basic woodworking equipment you will need a good-quality mitre saw, a frame clamp, an underpinner, a brad gun and a glasscutter. These can be purchased from some art and craft shops, hardware shops or through specialist suppliers. The framing book listed under *Further Reading* at the end of this book will give you more details about equipment and methods. Framing courses may be available locally in the form of evening or day classes run by an adult education centre, while other course centres are advertised in art magazines and directories, see *Further Reading and Resources*.

Other ideas for framing your watercolours are to renovate old frames bought from junk shops and market stalls, to use frame kits or clip frames, or to buy cheap framed prints and replace the print with your mounted painting. You can also order ready-made frames by post. Suppliers often advertise in art and craft magazines. Send for samples and details to check the quality and suitability before placing an order.

Displaying paintings

It is satisfying to see some of your paintings displayed around the house. Where and how they are hung is, of course, a matter for your own judgement, but there are one or two points to bear in mind when considering the siting of pictures.

Avoid placing a watercolour painting in a position where it will get a lot of full sunlight, as eventually exposure of this sort will cause fading and discolouration, both to the mount and the painting. In fact, the position of a picture with regard to the source of light, whether natural or artificial, is important. If it is placed such that the picture glass reflects various other items or parts of the room, the painting will be difficult to view. As a rough guide, where possible, hang pictures so that the centre of the painting is slightly below your eye level. Watercolours usually look better in groups rather than in isolation, particularly if they are small. The other point to watch out for is humidity and dampness. A painting placed against a cold stone wall, for example, will gradually pull out any dampness from the wall or, alternatively, trap condensation. Check the backs of paintings occasionally to see if there are any signs of dampness.

GLOSSARY

aerial perspective the suggestion of depth and recession, particularly in a landscape painting, by means of colour and paint-handling techniques rather than through the use of linear or measured perspective. The influence of atmosphere on a distant view is such that colours become diluted (weaker and cooler), tonal contrasts muted, and objects less defined. Colours often seem to acquire a bluish tinge as they recede.

airbrush a mechanical tool for creating finely controlled spray effects. Compressed air from a canister or compressor is mixed with thin paint and directed through an adjustable nozzle to make the spray. Watercolour can also be applied using a simple hinged spray diffuser. This will give a spattered, textured or fine spray.

alla prima painting (direct painting) a painting method in which colours and techniques are applied in one go, without any preliminary washes or further modification; the painting is usually completed in a single session

backruns the result of applying fresh paint against an area which is still wet. The new colour will fuse and run into the existing colour to create various accidental yet often interesting effects. Backruns can be used as a deliberate technique, especially for backgrounds.

bleed the blurring of the edges of an area of colour, sometimes caused by the type of paper, but more usually by painting wet-in-wet

blending the working together of adjacent colours in order to create a smooth, gradual transition from one colour to the next

body colour using gouache colours or mixing watercolour pigment with white gouache. Some watercolour artists like to use a little white gouache for highlights or add this to their watercolours to create various tints of opaque (dense, solid) colour which can be used as a contrast to the transparent washes of pure watercolour.

GLOSSARY 145

chiaroscuro dramatic contrasts of light and dark in a painting

chroma the richness or intensity of a colour; the quality of a colour resulting from the combination of its hue and saturation

complementary colours opposite colours on the colour wheel (see plate 3) which are generally accepted as being mutually enhancing. The complementary of any of the three primary colours is a mixture of the other two. Thus, red and green are complementary colours, as are yellow and violet, and blue and orange.

composition the design or organisation of the different elements and ideas to be expressed within a particular work of art

contre-jour painting usually, concerning a painting in which the subject matter is set against the light source and, consequently, the colour is low key with high-key accents and details

cool colour a colour associated with the sensation of cold, that is in the range of blue, blue-green and blue-violet

deckle the irregular edge of a sheet of handmade paper

drawing-in making an initial, usually outline, drawing on the water-colour paper from which to develop the work; this may be done in pencil or as a weak, fine-line brush drawing

dry-brush painting with just a little paint on the brush so that the colour only partially covers the paper, giving a broken colour effect. This works especially well with a flat brush for suggesting grass, foliage and other textures.

en plein air painting directly from the landscape in order to capture the actual effects of light and atmosphere

feather out using a fan brush or similar soft-haired brush to lightly blend and diffuse colours and reduce obvious lines and edges

fixative a type of thin varnish available in aerosol cans which is sprayed over soft pencil, pastel and charcoal drawings to prevent them smudging

focal point the area or individual object within a painting that most attracts attention. Usually the composition is so devised that shapes and lines lead your eye to a particular point.

Golden Section a proportion of approximately 5: 8 used in the composition of a painting. Therefore, the focal point or most obvious feature would come on a line roughly five-thirteenths of the way across the design

gouache opaque watercolour which consists of pure pigment in a gum binder with a white pigment or filler added to give the paint opacity. In contrast to pure watercolour it does not dry in a transparent way, with the underlying support influencing the colour. Rather, it dries as solid, flat colour which can be used to add details or to strengthen or contrast certain areas in the painting.

glazing thin overlaid washes used to create depth and richness of colour; this is the normal way of working in watercolour whereas in oil and acrylic painting it is an optional technique

gradated wash a wash that blends from light to dark, or vice versa, in the same colour

gum arabic a medium used as a binder for watercolour pigment. It is also available in bottled form and can be used as a supplementary medium in watercolour painting. For example, a small amount of gum arabic added to the water when mixing paint will give the colours more body and make them less likely to run and easier to blend. Additionally, it can be used as a varnish and as a means to revive dull areas of colour.

hard edge a wet wash applied to dry paper will normally form hard edges as it dries. Like backruns, this is a characteristic which can be used to advantage in a watercolour painting. However, if desired, hard edges can be avoided by working on damp paper or, alternatively, by softening the edges with a damp brush.

high key using bright, rich and warm colours and light tones

highlight a part of the painting that attracts or reflects the greatest amount of light; in a watercolour this is often a small patch of the white, unpainted paper

hot-pressed a type of paper which in its manufacture is rolled or pressed between hot metal plates; characteristically it has a smooth, sometimes slightly glazed surface

hue the actual colour (e.g. blue) as opposed to the tone or strength of colour

GLOSSARY 147

impasto thick, paste-like paint rather than a stain of colour

laid a type of paper characterised by vertical and horizontal lines in its structure, caused by the way the pulp has been pressed against a wire frame in its manufacture

laying-in applying preliminary washes of colour to organise the basic composition of the painting

local colour the actual colour of an object (e.g. a red apple) rather than the colour as influenced by different lighting conditions

low key using dull, dark and sombre colours

masking fluid a rubber compound solution which is painted on to particular areas to prevent them from accepting paint. Masking fluid is usually used to 'save' accents, fine lines and small details within an area that is going to be treated with a general wash. It can be applied over dry colour as well as to preserve patches of white paper. When the painting is finished the masking fluid can be rubbed off or peeled away.

medium any drawing or painting material, such as pencil, charcoal, pastel, and watercolour

mixed media combining several different drawing or paint media within the same piece of work

monochrome a painting which is confined to a range of tones of one colour

Not an abbreviation of 'not hot-pressed' and consequently a type of paper with a relatively coarse or open-surface texture

opaque not transparent; the use of solid areas of colour, with the lighter tones made by adding white rather than diluting the pigment

optical mixing using a mixture of small dabs of two or more colours across a particular area of the painting in order to give the overall effect of a single colour: for example, blue dots interspersed with yellow dots will suggest green

palette the selection of colours chosen to complete a painting. A limited palette is when just two or three tube or pan colours are used, with these intermixed to create whatever other colours are necessary. Also, of course, a palette is a mixing surface.

pigment paint

primary colour the three basic colours (red, yellow and blue) which cannot be mixed from any other source

rough heavy-quality paper

scumbling using a bristle brush to scrub dry paint unevenly over a previous colour in order to create a broken colour or textural effect

secondary colour a mixture of two primary colours, thus green, orange and violet

sgraffito scratching through one layer of colour with a sharp point or blade in order to reveal the colour or white paper beneath. This is a method frequently used in watercolour to create fine highlights, reflections on water or a slightly textural appearance in a given area.

soft edge working wet-in-wet or using a sponge, brush or other means to pull a wash across the dry surface of the paper so that it dries without obvious hard edges

spattering paint applied as random specks of colour either on to a wet or dry surface. This is done by dipping an old toothbrush or a stiff-haired bristle brush into a little paint, holding it upright in front of the area to be treated, and pulling back the bristles with your forefinger to create the spray effect.

stippling a method of applying paint either as a light, general texture or as a series of separate small dots of colour. Individual dots are applied with the tip of a fine, pointed brush; while alternatively a larger brush can be used, charging it with just a little paint and lightly stabbing it up and down across the relevant area.

stretching preparing the watercolour paper by wetting it and taping it down to a board

support painting surface, usually different types of paper

texture a slightly rough surface feeling or appearance to the paint created either by using a heavy-quality paper or by applying the paint with a sponge or using techniques such as dry-brush, scumbling and spattering

tidemark obvious dark outlines left around and sometimes within areas of wash. These are usually caused where paint has been allowed

GLOSSARY 149

to 'puddle' and has consequently dried unevenly or where a wash hasn't been applied quickly enough so that some parts have partly dried before the whole area of wash has been completed

tint stain of colour; greatly reduced colour made by diluting the original pigment with a lot of water, or a light tone made by mixing colour with white

tone the light or dark value of the colour

tooth the coarseness or texture of the surface of the paper

transparency a characteristic of watercolour paints is that the colours transmit rather than reflect light. This means that to varying degrees the whiteness of the paper shows through and influences the colours and painting effects.

underdrawing lightly sketching in a preliminary drawing or guide lines to establish the main areas of the composition

underpainting the initial stage of painting which is usually a series of general washes applied to block in the main parts of the composition; subsequently, further washes and other effects are worked over these

value the strength of colour in terms of light or dark

warm colour a colour associated with the sensation of warmth, that is in the range of red, purple, orange or orange-yellow

wash pigment diluted to a fluid state and lightly applied to the paper surface

wet-in-wet working wet colour into or over a wet layer already on the paper

wet-over-dry working wet washes over colour which has already dried

wove paper that is made against a closely woven wire mesh so that no obvious surface texturing or internal pattern structure is noticeable

FURTHER READING AND RESOURCES

Books

The following recently published books cover various watercolour painting topics in more detail:

An Introduction to Watercolour, D K Art School Series (Dorling Kindersley)

Big Brush Watercolour, Ron Ranson (David & Charles, UK)

Collins Creative Watercolour Techniques, (HarperCollins, UK)

Complete Book of Watercolour, The, José M Parramón (Phaidon, UK)

Developing Style in Watercolour, Ray Campbell Smith (David & Charles, UK)

Developing Your Watercolours, David Bellamy (HarperCollins, UK)

Everything You Ever Wanted to Know About Watercolour, Marian Appellof (Batsford, UK)

Enliven Your Paintings With Light, Philip Metzger (North Light Books, USA)

First Steps: Painting Watercolors, Cathy Johnson (North Light Books, USA)

Framing, Moyra Byford (Search Press, UK)

Fresh Watercolour, Ray Campbell Smith (Sterling Publishing, USA)

Learn to Paint (a series of books published by HarperCollins, UK, which includes various titles on watercolour subjects, such as Flowers, Gardens, Outdoors, Light, and Farm Animals)

Light in Watercolor, Lucy Willis (Watson-Guptill Publications, USA)

Magic of Watercolour, The, James Fletcher-Watson (Batsford, UK)

Mastering Watercolour, various contributors (Batsford, UK)

100 Great Watercolour Tips, Miranda Fellows (Batsford, UK)

Painting Animals in Watercolour, Sally Mitchell (Search Press, UK)

Painting in Watercolours, Yvonne Deutch (Search Press, UK; Arthur Schwartz & Co, USA)

Teach Yourself Drawing, Robin Capon (Hodder & Stoughton, UK; NTC Publishing Group, USA)

The Artistic Touch: Ideas & Techniques, Christine M. Unwin (Creative Art Press, USA)

Transparent Watercolor Wheel, Jim Kosvanec (Watson-Guptill Publications, USA)

Watercolor Breakthroughs, Rachel Wolf (North Light Books, USA)

Watercolor Class, Michael Crespo (Watson-Guptill Publications, USA)

Watercolour Colour, D K Art School Series (Dorling Kindersley)

Watercolour Fast and Loose, Ron Ranson (Sterling Publishing, USA)

Watercolour for All, Ray Campbell Smith (David & Charles, UK; Reader's Digest, USA)

Watercolorist's Garden, The, Jill Bays (Sterling Publishing, USA)

Watercolour Impressionists, Ron Ranson (David & Charles, UK)

Watercolour Landscape Course, David Bellamy (HarperCollins, UK)

Watercolour Landscapes from Photographs, Ron Ranson (Watson-Guptill Publications, USA)

Watercolour Painting Techniques, Sue Sareen (Watson-Guptill Publications, USA)

Watercolour Step-by-Step, Hazel Harrison (HarperCollins, UK)

Watercolour Still Life, D K Art School Series (Dorling Kindersley)

Watercolour Tips & Tricks, Zoltan Szabo (David & Charles)

Watercolour Troubleshooter, Don Harrison (Barron's Educational Series, USA)

Watercolour Workbook, Anne Elsworth (David & Charles)

Watercolour Workshop, John Lidzey (North Light Books, USA)

Watercolourist's Complete Guide to Colour, The, Tom Hill (Studio Vista)

Wet-into-Wet, Bryan A Thatcher (Arthur Schwartz & Co, USA)

Instructional magazines

United Kingdom

Send for a sample copy and subscription details:

The Artist, 63-65 High Street, Tenterden, Kent TN30 6BD

The Artist's and Illustrator's Magazine, 4 Branden Road, London N7 9TP Leisure Painter, 63–65 High Street, Tenterden, Kent TN30 6BD United States

Artists' Magazine, F & W Publication Inc., 1507 Dana Avenue, Cincinnati OH 45206

Draw Magazine, Calligrafree, 43 Anaka Avenue, Box 98, Brookville OH 45309

Illustration, Art Instructive Schools, 500 South Forth Street, Minneapolis MN 55415

Demonstration videos

Send for a list of titles:

APV Films, 6 Alexandra Square, Chipping Norton, Oxon. OX7 5HL

Teaching Art Ltd, P.O. Box 50, Newark, Notts NG23 5GY

Courses in United Kingdom

Useful directories:

Art & Design Courses, up-to-date information and details about further education courses, published by Trotman & Co Ltd, 12 Hill Rise, Richmond, Surrey, TW10 6UA

Painting Holiday Directory, details of painting holiday courses in the UK and abroad, published by PHD Publications, P.O. Box 1, Ponteland, Newcastle NE19 2EB. In the United States contact PHD Publications, P.O. Box 2152, Stamford, Connecticut 06906.

Time to Learn, a directory of summer learning holidays, published by The National Organisation for Adult Learning, 21 De Montfort Street, Leicester LE1 7GE.

Classes, courses and art societies in United States

For an extensive list of art museums, schools and associations in the USA and Canada, consult the *American Art Directory*, published by R.R. Bowker Co., 245 West 17th Street, New York NY 10011.

Educational and instructional opportunities – schools, colleges, workshops and private teachers – are listed in *The Artist and Art School Directory*, published by Billboard Publications Inc., 1515 Broadway, New York City NY 10036.

The Painting Holiday Directory, PHD Publications, P.O. Box 2152, Stamford, Connecticut 06906 lists holiday painting courses.

INDEX

Numerals in italics refer to illustration numbers

frames 141

abstracts 9, 126-8, 52, 53 materials 12 adding water 29, 67, 9 mounts 138 aims in painting 89 sketchbooks 73 alla prima 53 chroma 29 analogous colours 31 Claude 7 artists' watercolours 13 cleaning brushes 18 cold-pressed paper 18 atmospheric effects 6, 8, 49, 50, 81, 108, *1* colour 28 ff contrasts 37 background 91, 98, 108 experiments 15 backing watercolours 140 intensity 30, 37, 9 backruns 67 pencils 77 basic materials and equipment 25 colour wheel 31, Plate 3 basic techniques 40 ff combination brushes 16 Blake 8 combing techniques 5, 65, 67 blending 50, 69 composition 72, 90, 100, 102, blotchy washes 69 116, 119, 120 Bockingford paper 18, 2 conservation framing 137 brush and wash 83, 34 Constable 8 brushes 15, 16, 42, 53, 54, 55 cool colours 34 cartridge paper 41, 73, 40, 51 Cotman 1, 2, 8, Plate 1 Cézanne 9 counterpoint 37 characteristics of watercolour 1. Cox 8, Plate 2 2, 3, 5, 67 Cozens 1, 8 charcoal 77, 84, 11, 30, Plate 5 cutting out 61 Chinese brushes 16 dabbing 61 Chinese calligraphy 7 De Wint 8 Chinese white 56 Delacroix 8 choosing details 6, 69, 93 Plate 7

displaying paintings 143 **Grand Tour 8** distance 34, 98, 99, 107, 13 granulation 47 double mounts 140 gum arabic 6, 7, 64 drawing board 24 harmonious colours 31, 37 dropper 67 high key 37 dry-brush 47, 53, 54, 59, 65, 23, history of watercolours 7 ff honey 6 dry stretching paper 21 Hopper 9 dull paintings 69 horizon 98, 99 Dürer 7 hot-pressed paper 18, 89 hue 29 easels 24 enlarging 91, 116, 48, 49 Ideas 86, 87, 107 equipment 22 ff, 105, 7, 55 imagination 122, 125 erasers 76, 78, 7 ink and wash 48, 83, 20, 33 evaluation 134 inspiration from other artists 88 exhibitions 2, 5, 88, 131 experimenting with techniques 123 Jongkind 9 exploring watercolour 9 Kandinsky 9 expressive colour 38 Kolinsky sable brushes 15 eye-level 98, 99 landscape painting 72, 105, 1, 2, 12, 22, 26, 27, 28, 40, 47, 52, fantasy 125, 126 figures 108, 109, 44, Plate 12 54, and Plates 1, 2, 6, 7, 8 learning from experience 131 fixative 78, 81 lifting out 47, 55, 56, 67, 46 flat wash 41, 43, 14 light 102 focal point 100 lightfastness 6 foregrounds 108, 112 lights and darks 101, 102, also see foundation washes 36 framing 136 ff, 68 tone limited palette 2, 15, 29, 37, 52, framing ideas 142 further reading 9 Plate 8 line and wash 7, 48, 67, 82, 20, 33, Gainsborough 8 34 galleries 2, 88, 122, 131 line drawing 75 Girtin 1, 8 local colour 32 glycerine 6, 13 location Golden Section 100 notes 75 gouache 5, 24, 55, 56, 62, 27, 47 painting 82 gradated wash 43, 15 sketches 88, 41

looking at other paintings 131 low key 37, 108 masking fluid 24, 55, 56, 58, 64, matching colours 31 miniatures 7 mixed media 67, 83, 28 mixing colours 28, 30, 31, 32, 10, Plate 4 mixing washes 40-7 muddy colours 32, 62, 69 Not papers 18, 49, 89 notebook 132 observation 71, 74, 84, 97 ff, 122 opaque effects 62, 65 outdoor equipment 106, 55 outline drawing 71, 90, 102, 119, ox gall liquid 64 paintbox 3 painting from sketches 115 painting outdoors 105 ff paints 6, 13 palette 15, 22 Palmer 1, 8 pan colours 13, 14 paper 18, 19, 41, 46, 61, 69, 80, 82, 89 paper surfaces and textures 18 parchment 7 pastels 81 pen and ink 67, 80 pencil and wash 48 pencils 76, 29

pens 78, 31, 32

permanence 6

personal style 10, 65, 130, 134, 1 perspective 98, 99, 39 photographs 75, 88, 108, 115, 118, 50, 51 pigment 6, 7 pipette 67 planning paintings 86 ff, 90 preliminary sketches 71, 72, 88, 97, 35 primary colours 29, 82, Plate 4 progress in painting 2 projects 3, 10, 26, 38, 58, 70, 85, 96, 104, 114, 121, 129, 135 proportions 97, 98 quick sketches 75 reasons for painting 1 reference studies 8, 71, 72, 82, 132 Reid 9 Rembrandt 8 research 88, 124 reserved whites 55 rough paper 18, 89 rough sketches 87 Rowlandson 8 Sable 15 salt 61 Sandby 1 Sargent 9 scale 98, 108, 40 scrapbook 126 scratching through 55, 56, 60, 24, Plate 11 secondary colours 30 self-criticism 134 shadows 32, 92, 95, 101 sketchbook 2, 22, 71 ff, 82, 132

sketching 71 ff materials 22 media 75 ff with watercolour 81, 1, Plate 5 skies 10, 45, 46 space 107 spattering 60 special effects 93 split-brush 61 sponge 13, 24, 47, 49, 61 squaring-up 116, 48, 49 stages of painting 93, 35-8, Plates 9 and 10 stipple 55 stretching paper 19, 20, 21, 89, 5-6 structure 97 students' watercolours 13 subject matter 86, 87 synthetic hair brushes 16 techniques 40 ff testing brushes 16, 4 testing papers 89 texture medium 64

synthetic hair brushes 16

techniques 40 ff
testing brushes 16, 4
testing papers 89
texture medium 64
textured paper 46
textures 59, 65, 97, 25, 26
three-dimensional form 32, 34, 52, 95, 18
tone 9, 29, 34, 37, 52, 72, 80, 97, 108, 11, 12
Towne 8
traditional watercolour 5, 8, Plate 1
tube colours 13
Turner 1, 8

vanishing point 99 variegated wash 45 versatility in watercolour 9, 59 viewfinder 107 viewpoints 72

warm colours 34 washes 6, 8, 9, 32, 40 ff, 58, 92, 95, 110, 120, 8, 18, 19 washes and drawing media 67 water containers 23 watercolour medium 64 water-soluble pencils 77 wax resist 59-60, 67, 26, Plate 4 weak colour 67 wet-in-wet wash 44, 49 ff, 67, 17, 21, 22, 45, Plates 8 and 11 wet-on-dry 52 whites 55 window mounts 139 working from memory 124 working through stages 90